DRAWING
MANGA
HEROINES
& HEROES

An interactive guide to drawing anime characters, props, and scenes step by step

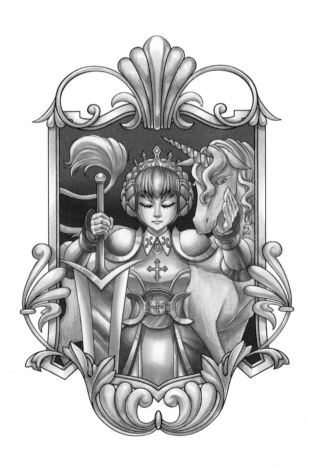

Walter Foster

Brimming with creative inspiration, how-to projects, and useful information to enrich your everyday life, Quarto Knows is a favorite destination for those pursuing their interests and passions. Visit our site and dig deeper with our books into your area of interest: Quarto Creates, Quarto Cooks, Quarto Homes, Quarto Lives, Quarto Drives, Quarto Explores, Quarto Gifts, or Quarto Kids.

© 2019 Quarto Publishing Group USA Inc.
Artwork and text © 2019 Sonia Leong

First published in 2019 by Walter Foster Publishing, an imprint of The Quarto Group.
26391 Crown Valley Parkway, Suite 220, Mission Viejo, CA 92691, USA.
T (949) 380-7510 F (949) 380-7575 www.QuartoKnows.com

Walter Foster Publishing titles are also available at discount for retail, wholesale, promotional, and bulk purchase. For details, contact the Special Sales Manager by email at specialsales@quarto.com or by mail at The Quarto Group, Attn: Special Sales Manager, 100 Cummings Center, Suite 265D, Beverly, MA 01915, USA.

ISBN: 978-1-63322-804-7

Digital edition published in 2019
eISBN: 978-1-63322-805-4

Printed in China
10 9 8 7 6 5 4 3 2 1

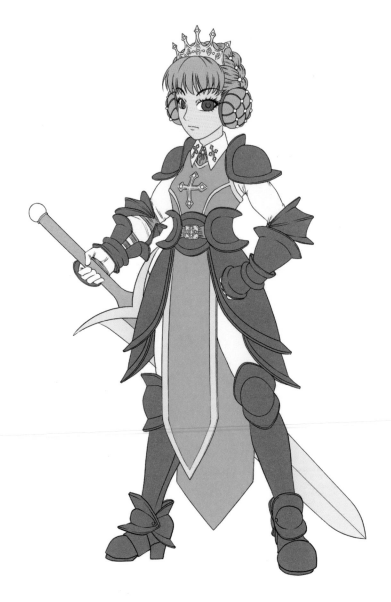

TABLE OF CONTENTS

INTRODUCTION

ONE REASON WHY YOU LOVE MANGA IS PROBABLY ALL THE AMAZING CHARACTERS. MANGA IS APPEALING FOR ITS HUGE VARIETY OF PROTAGONISTS WITH EPIC STORYLINES THAT ARE DRAWN IN DIFFERENT STYLES AND ACROSS SO MANY SETTINGS. NO MATTER WHAT KIND OF MANGA STORIES YOU LIKE TO READ, YOU'RE BOUND TO FIND A SERIES THAT APPEALS TO YOU! AND IF YOU HAVEN'T FOUND A MANGA STORY YOU LOVE, WHY NOT CREATE YOUR OWN?

THIS BOOK FOCUSES ON HOW TO CREATE MAIN CHARACTERS FOR MANGA STORIES, AND IT TEACHES YOU THE FUNDAMENTALS BEHIND DESIGNING AND DRAWING A WIDE RANGE OF MANGA HEROINES AND HEROES. DRAW A CUTE MAGICAL GIRL BALANCING SCHOOL LIFE WITH FIGHTING CRIME (SEE PAGES 26-33) OR A HARDENED BOUNTY HUNTER TRAWLING THROUGH SPACE DEBRIS (PAGES 106-111)—AND MUCH, MUCH MORE! THE SETTINGS AND SITUATIONS AFFECT A CHARACTER'S APPEARANCE AND PROPS; LEARN HOW WITH THE HELP OF THIS BOOK.

FEATURED IN THE BOOK ARE DEVELOPMENTAL SKETCHES WITH VISIBLE CONSTRUCTION LINES, CLEAN SHOWCASES OF COMPLETE CHARACTER DESIGNS, STEP-BY-STEP BREAKDOWNS OF BEAUTIFUL COVER AND SPLASH ILLUSTRATIONS, AND GUIDED ACTIVITIES THAT ALLOW YOU TO EXERCISE YOUR IMAGINATION AND PRACTICE KEY DRAWING SKILLS.

NOW LET'S CREATE THE HEROINES AND HEROES OF TOMORROW!

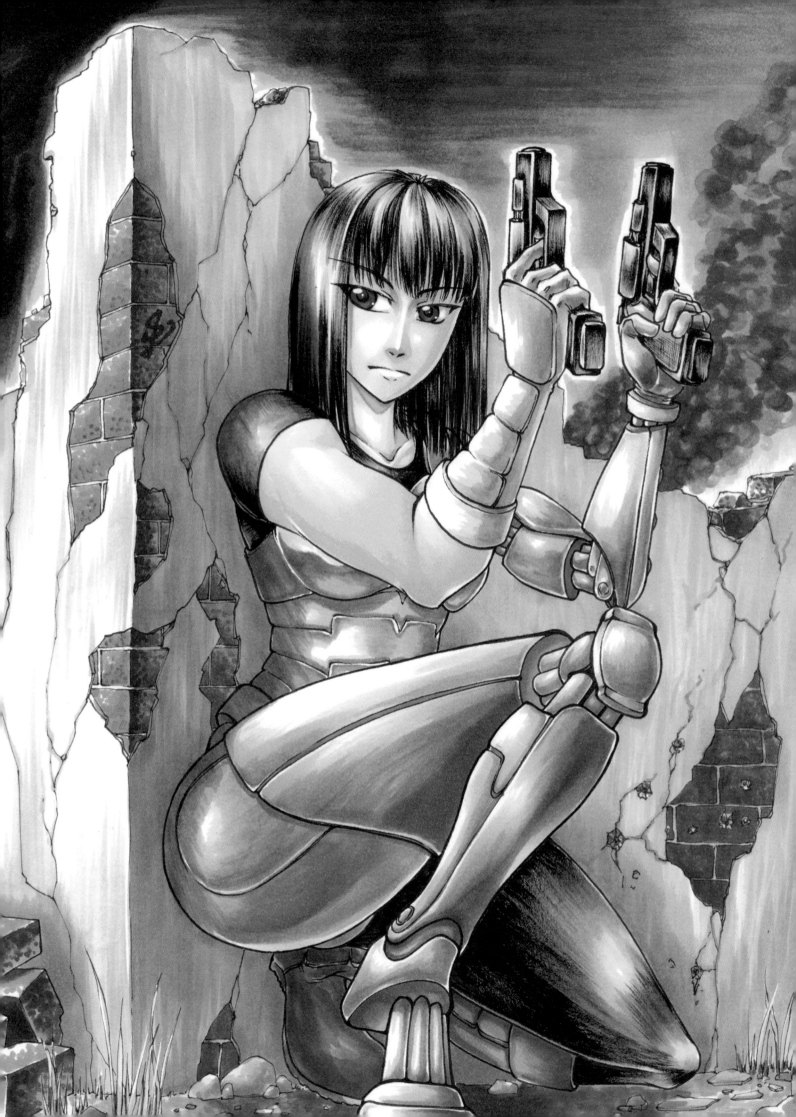

TOOLS & MATERIALS

YOU PROBABLY ALREADY HAVE A LOT OF THE TOOLS TO DRAW MANGA. IF YOU BUY PROFESSIONAL ITEMS, INVEST IN TOOLS THAT WILL LAST. LESS EXPENSIVE OPTIONS WORK WELL TOO. THE FOLLOWING IS JUST A QUICK LIST OF SOME OF THE TOOLS YOU MIGHT WANT TO USE. MORE DETAILS ON HOW TO USE EACH ITEM ARE INCLUDED THROUGHOUT THE BOOK.

PENCILS & SKETCHING

Pencils: These are the most common and versatile tools. HB, B, and 2B pencils are easy to use and can add contrast. A mechanical pencil is great for sketching but not for shading, because its point stays thin.

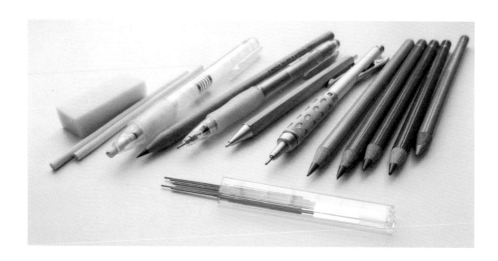

Non-photo blue/non-repro blue pencil lead: These brightly colored leads aren't visible when photocopied, so they work well for sketches, which can then be inked over in your final drawings.

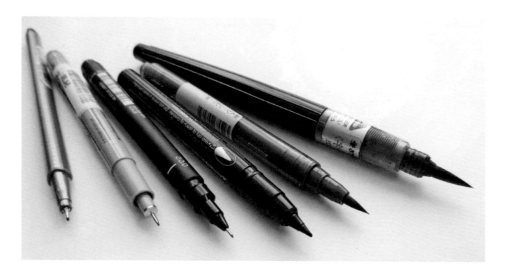

BRUSHES, PENS & INKS

Manga is predominantly a black-and-white medium. Even when the art is colored in, it usually features crisp black outlines, so most manga artists prefer to use pure black ink.

Fineliners: These come in different widths and are easy to use, making them the ideal drawing tool for a beginning manga artist.

Brush pens: Placing more pressure on the brush will thicken your lines, while light pressure produces very fine details.

Dip pens: Dip pens are the traditional tool for a professional illustrator. Metal nibs are perfect for manga artwork; by changing pressure, you can go from super-fine, feathery lines to thick, bold strokes.

Brushes: These produce thicker lines than nibs, as well as drybrushed textures for shading.

ADDING COLOR

Colored pencils: When used in layers, these can create shading. Sharpen them for outlines and strong details. A chiseled tip is great for shading.

Markers: The most popular tool for coloring manga remains the marker. Keeping your strokes wet as you go over them again makes them look smooth and blended, or let the strokes dry first before adding more to create a distinct darker layer without blending.

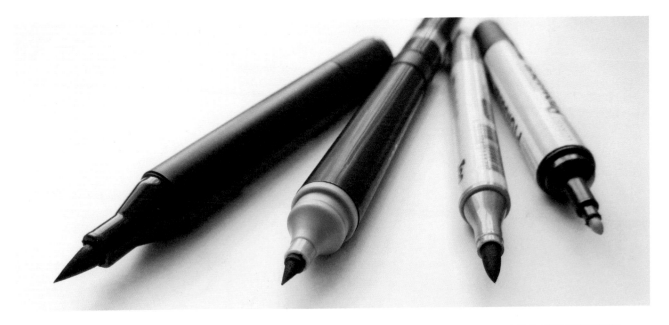

DIGITAL TOOLS

You can also digitally sketch, ink, shade, and color your manga drawings. This book focuses on more traditional techniques, such as drawing and inking by hand; however, you might want to look online for digital art suggestions. (See page 15 to learn how to add color digitally.)

DRAWING BASICS

A GOOD MANGA ARTIST UNDERSTANDS WHAT REAL-LIFE OBJECTS LOOK LIKE AND CHOOSES TO DRAW THEM USING ONLY A FEW LINES.

FACES

To draw a character's face, start with an egg shape, and then lay crosshairs over it to represent the head. Place the facial features within these guidelines, shrinking or stretching them as necessary according to the angle of the head. Then shape the hairstyle around the head.

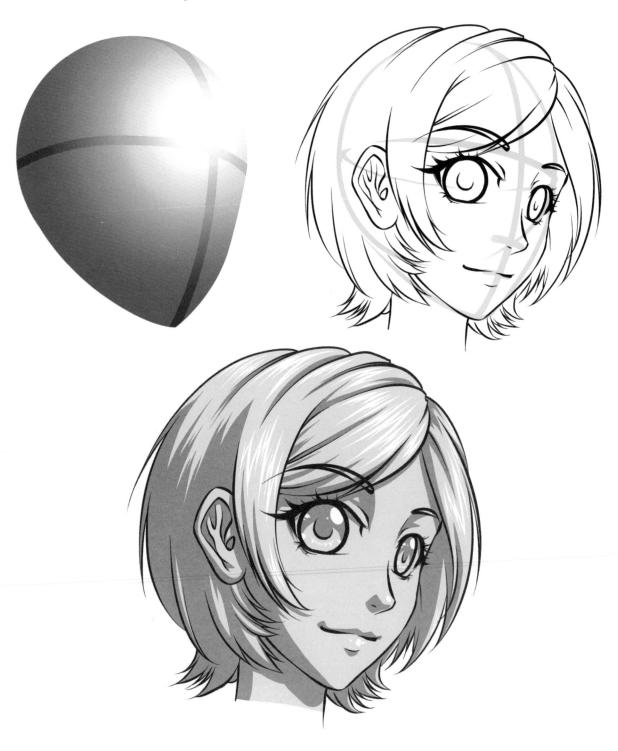

SHAPES & RATIOS

Look at the objects around you, and simplify them into basic shapes, such as spheres, pyramids, and cylinders. Imagine that you are sculpting an object from clay. What shape would you start with? Then look for ratios that divide your subject into sections, which will help you place the subject's features. Is a certain element positioned halfway or a third of the way down from the top?

KEY RATIOS

Here are some helpful guidelines to keep in mind when drawing a head.
- The head looks like a sphere with the chin protruding from the bottom, like an egg.
- Eyebrows go halfway down the sphere, along the crosshairs.
- Place the tip of the nose halfway between the eyebrows and the chin.
- The mouth sits halfway between the nose and chin.
- Eyes lie in the center of the head.
- The tops of the ears are level with the eyebrows; earlobes are level with the nose.
- Shape the hair around the whole lead; it must be larger than the egg shape.

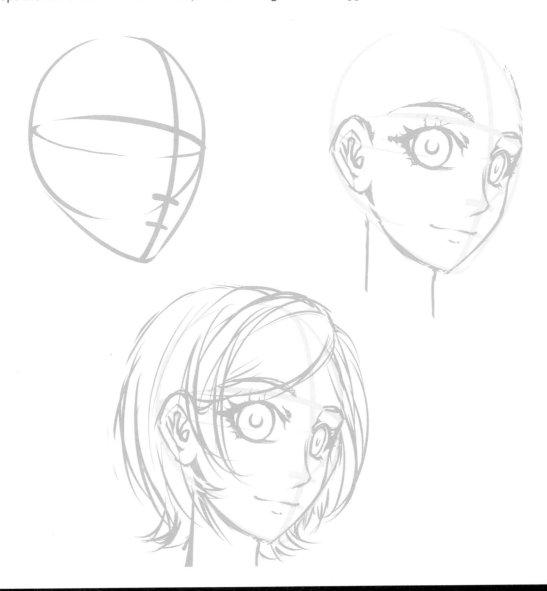

BODIES

In order to get the proportions, balance, and movement right in a character, try drawing it as a stick figure before adding any additional details. Adding shapes over a stick figure is a great way to flesh out its large muscle groups and joints. Then add clothes on top.

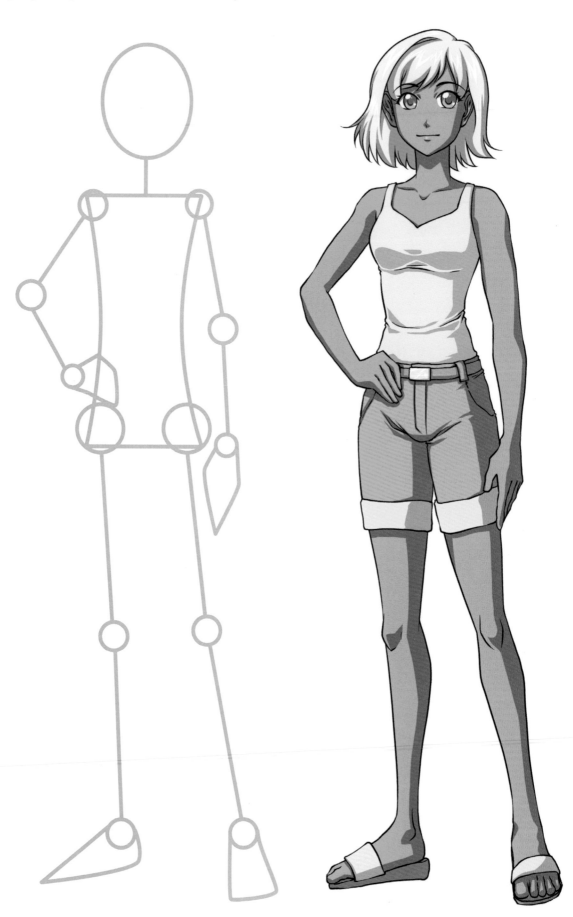

KEY RATIOS

Keep the following tips in mind when drawing bodies.

- Legs make up roughly half of a character's height. Feet extend from the legs.
- Arms are about the same length as the torso, with the hands extending from the arms.
- Elbows lie halfway between the shoulder and the wrist.
- Knees go halfway between the hips and ankles.

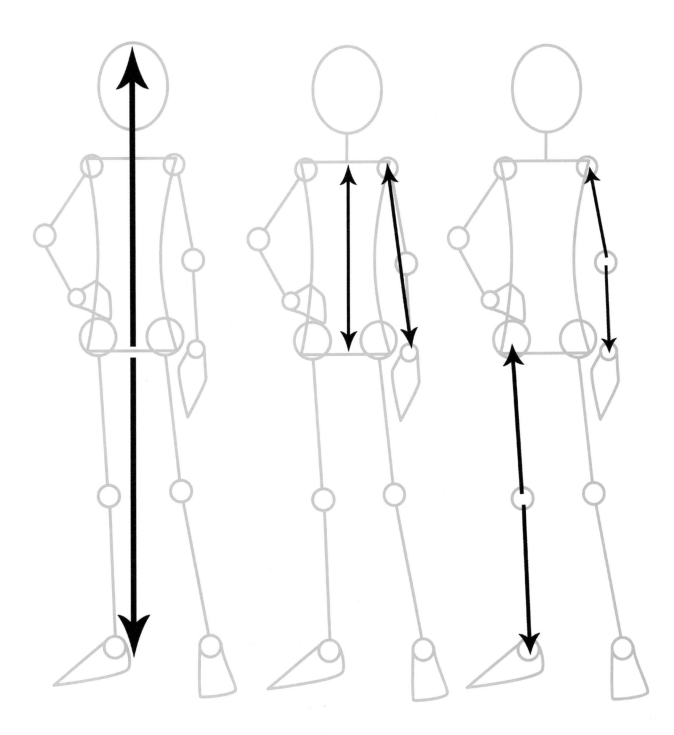

INKING BASICS

WHETHER OR NOT YOU ADD COLOR TO YOUR FINAL DRAWINGS, THE INK LINES WILL REMAIN VISIBLE, SO YOU WILL USE THEM TO CONVEY TEXTURE, VOLUME, AND DEPTH. HERE ARE SOME TIPS.

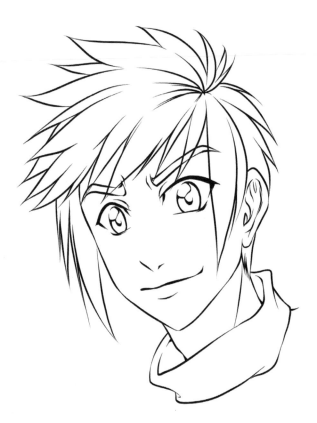

Tapered ends: Complete your lines by lifting or flicking the pen upward to create a super-thin finish, particularly when drawing hair. Inking too slowly and pressing too hard causes the ink to pool and blunts the ends of your lines.

Distance: When drawing an object that should appear closer to the viewer, use thicker ink lines. Thinner lines create a delicate, faded appearance that's suitable for a distant object.

Convex edges: To add the appearance of volume and lighting, narrow your lines or leave gaps at any rounded, convex edges that face a light source.

Object order: Thicken the lines of the object at the front of a drawing, and keep in mind that the object in front will cast a shadow onto anything behind it. For a very distant background object, taper out its lines or leave a subtle white border around the object in the foreground.

These simple shapes clearly demonstrate depth, volume, and lighting through the use of line width variation and tapered ends.

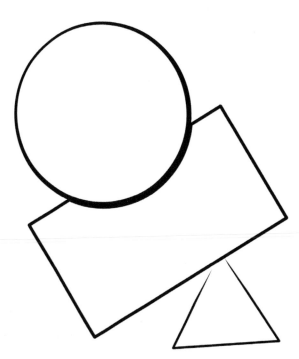

SHADING

BY ADDING SHADOWS AND HIGHLIGHTS, YOU CAN CREATE VOLUME AND DEPTH IN A DRAWING AND BRING IT TO LIFE. AS YOU DRAW, THINK ABOUT THE DIRECTION OF THE LIGHT SOURCE.

TIPS FOR SHADING

- First, pick a light source.
- Highlight the surface closest to and facing the light source.
- Surfaces that are more distant and facing away should be in shadow.
- Objects in front will cast a shadow onto anything behind them.

Look at some simple shapes. Here, the light source is marked with an arrow. See how the top right of the ball is highlighted and fades into shadow in the bottom left, casting a shadow onto the floor beneath it.

Once you're comfortable shading simple shapes, look at your favorite professionally done drawings and notice how more complicated subjects are shaded.

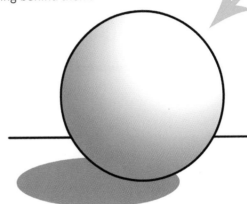

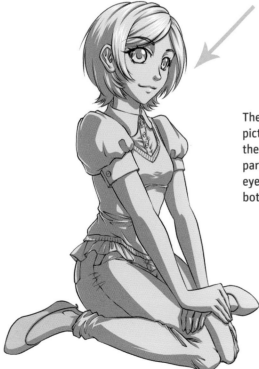

The light source is the same in this picture. Highlights have been placed in the top-right portions of the girl's body, particularly on shiny surfaces, like her eyes and hair. Notice the shadows in the bottom-left areas.

COLORING

TRADITIONAL MANGA ART IS DONE IN BLACK AND WHITE, BUT COMIC BOOK COVERS, PROMOTIONAL IMAGES, AND STANDALONE ART ARE OFTEN COLORED IN. HERE ARE SOME TIPS FOR USING COLORED PENCILS, MARKERS, AND DIGITAL TOOLS TO COLOR IN YOUR MANGA ARTWORK.

COLORED PENCILS

Outline the subject using darker shades of colored pencils.

Use sharp pencils for fine detailing.

Be consistent with the directions of your lines and follow the contours of your drawing surface.

Layer colors for a rich, vibrant look.

MARKERS

Overlap your strokes for smooth blending and to avoid streaks when filling in large areas.

Work quickly to fill in the shadows on the face; then go over them with a lighter color for a seamless fade.

Leave the paper white and feather out your strokes to showcase soft highlights.

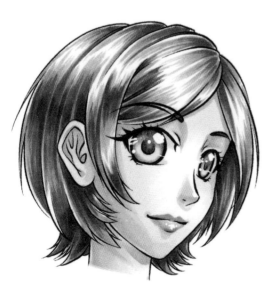

Let the previous layers dry, and then add darker shades and small, bright highlights with white ink.

DIGITAL COLORING

Use a graphics tablet or tablet computer with a stylus to draw fine details using a natural hand position.

Use software that lets you work in layers. Set the line art layer to "multiply" so that you can see any midtone colors added to the base layers underneath.

Add a layer above the midtone base and draw in strong, colorful shadows for contrast.

Add shadows and highlights to additional layers, where needed.

SCHOOLGIRL

NOW LET'S USE THE SKILLS YOU'VE LEARNED OVER THE LAST FEW PAGES TO BEGIN DRAWING YOUR OWN MANGA CHARACTERS, STARTING WITH THE SCHOOLGIRL. FROM HORROR STORIES AND ACTION-PACKED THRILLERS TO ROMANCES, MANY MANGA COMICS ARE SET IN SCHOOLS, MAKING THE SCHOOLGIRL AN ICONIC HEROINE. HERE ARE SOME TIPS FOR DRAWING HER TRADEMARK OUTFIT.

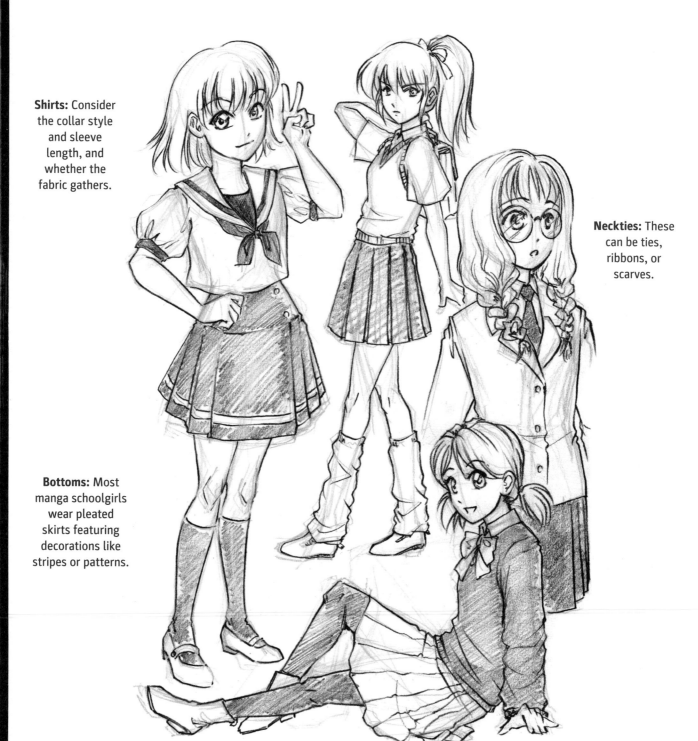

Shirts: Consider the collar style and sleeve length, and whether the fabric gathers.

Neckties: These can be ties, ribbons, or scarves.

Bottoms: Most manga schoolgirls wear pleated skirts featuring decorations like stripes or patterns.

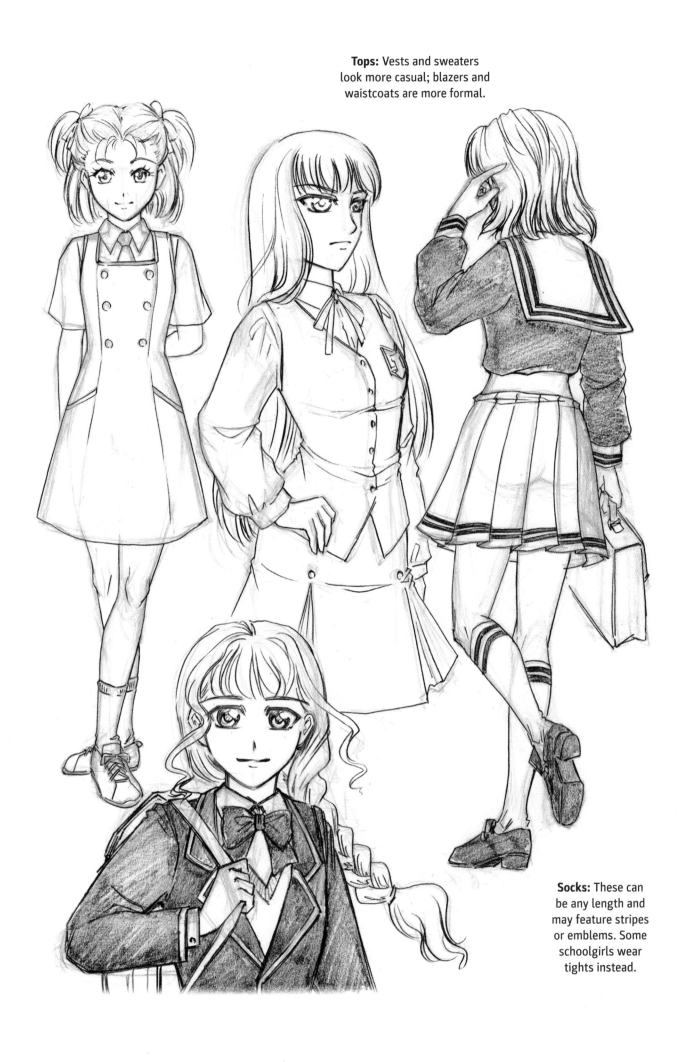

Tops: Vests and sweaters look more casual; blazers and waistcoats are more formal.

Socks: These can be any length and may feature stripes or emblems. Some schoolgirls wear tights instead.

CHARACTER SHOWCASE: ANGELA THE SCHOOLGIRL

A bubbly girl, Angela is well-liked by her classmates. She goes to an elite school with a distinctive uniform in navy and red. Her blazer looks sharp, and her socks match her tartan skirt.

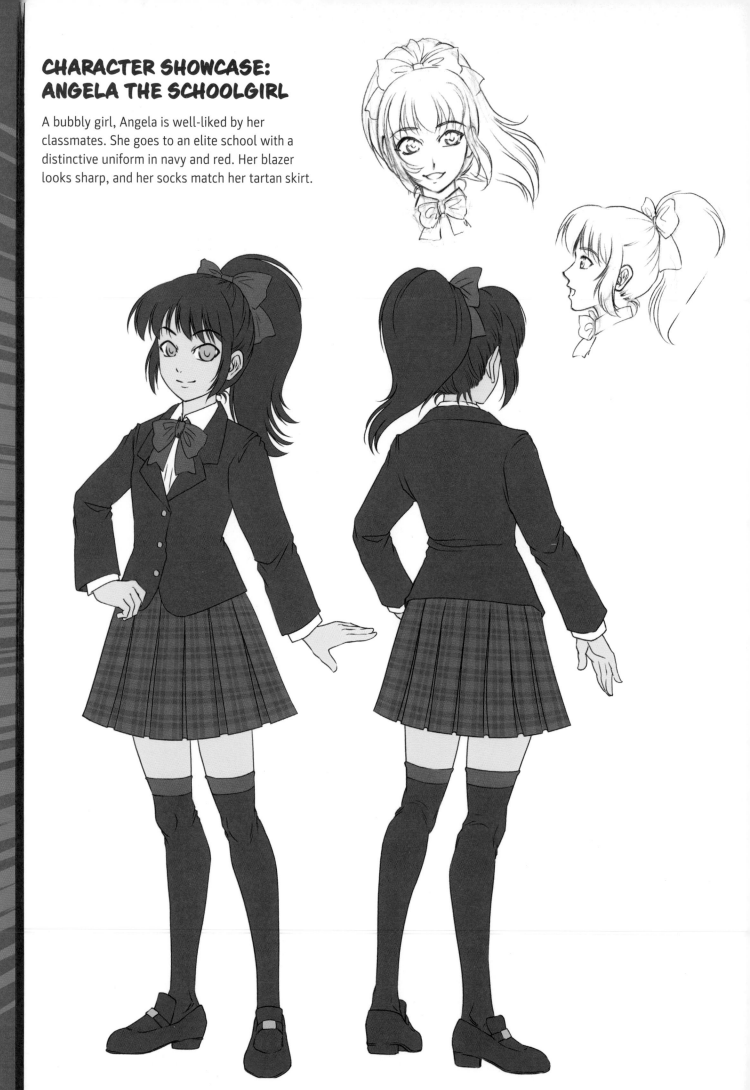

PRACTICE HERE!

What if Angela transferred to a different school? Try creating a new uniform for her.

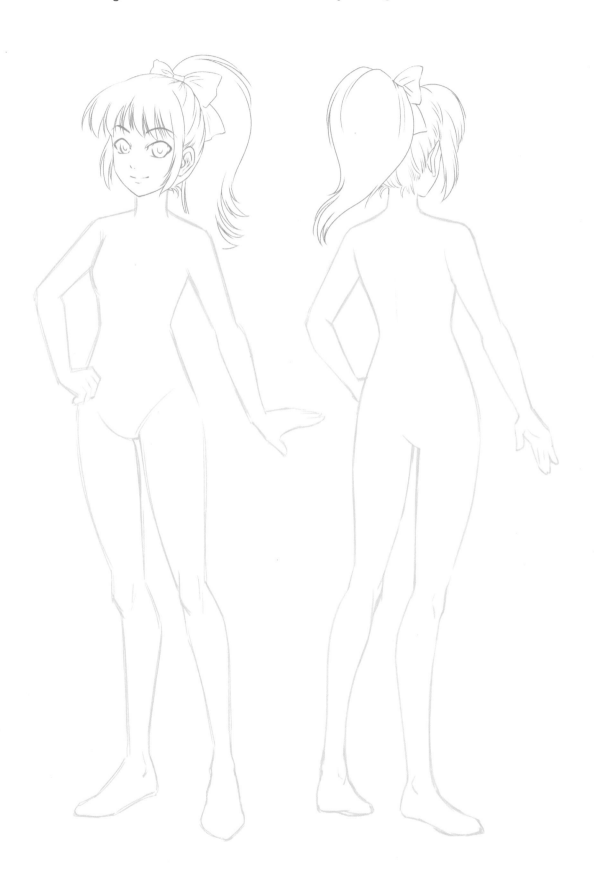

SCHOOLBOY

JUST AS POPULAR AS THE SCHOOLGIRL, THE SCHOOLBOY IS OFTEN THE MAIN CHARACTER IN CONTEMPORARY MANGA SERIES. HIS UNIFORM WILL ALSO VARY ACCORDING TO THE SCHOOL HE ATTENDS AND HIS STYLE.

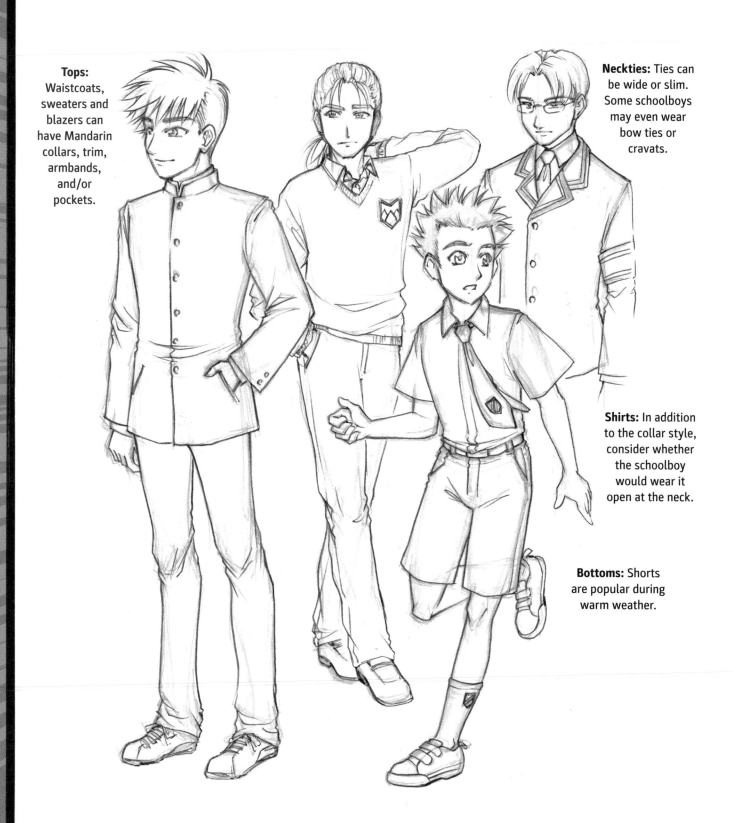

Tops: Waistcoats, sweaters and blazers can have Mandarin collars, trim, armbands, and/or pockets.

Neckties: Ties can be wide or slim. Some schoolboys may even wear bow ties or cravats.

Shirts: In addition to the collar style, consider whether the schoolboy would wear it open at the neck.

Bottoms: Shorts are popular during warm weather.

CHARACTER SHOWCASE: ADAM THE SCHOOLBOY

Adam goes to the same school as Angela (page 18), so his suit and tie have the same navy-and-red color scheme. His blazer is cut longer than the girls' version, however, and he has a worried look on his face.

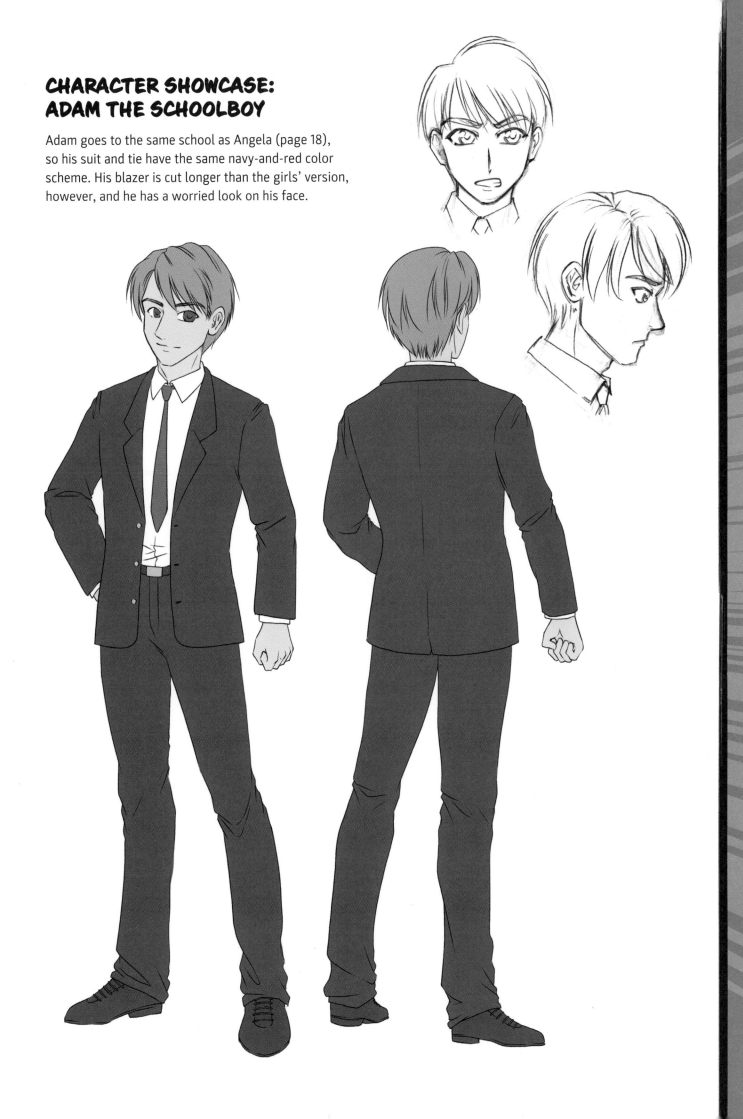

STEP-BY-STEP: SCHOOLGIRL & SCHOOLBOY

LET'S COMBINE THE CHARACTERS, FACIAL EXPRESSIONS, AND CLOTHES WE DISCUSSED ON PAGES 16-21 AND DRAW A PORTRAIT OF THE SCHOOLGIRL AND SCHOOLBOY TOGETHER!

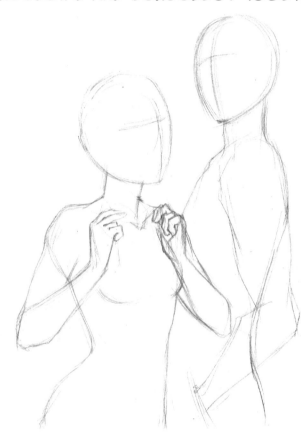

Roughly and lightly lay out your figures in pencil. Mark the main muscle groups and tricky elements, such as the hands.

I used pencil, fineliner pens, markers, and white gel pens on 200gsm cartridge paper.

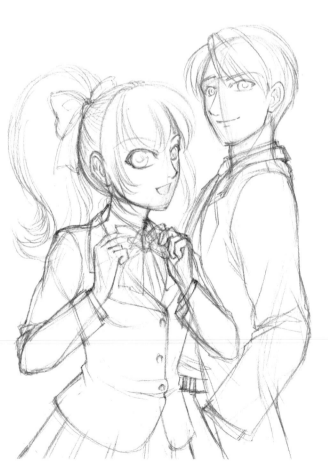

Add details to your sketch, including facial features, hair, and clothing.

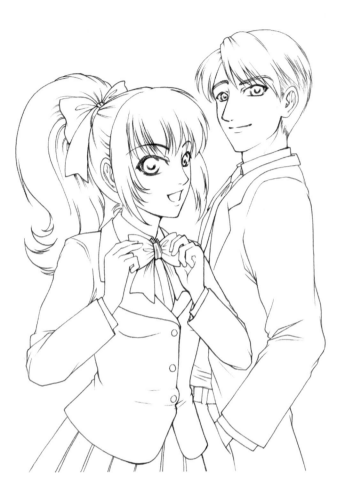

Go over your pencil lines with fineliner pen. Let the ink dry; then carefully erase your pencil marks without damaging the paper.

Color in the characters' skin, softly fading out for subtle highlights.

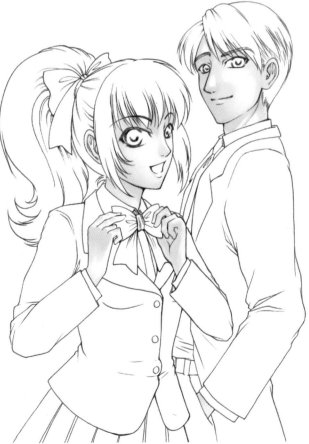

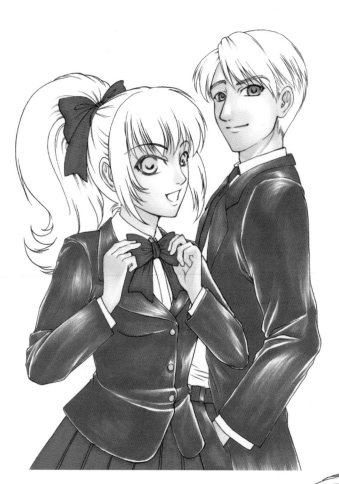

Fill in the midtones on the darker, more matte areas, such as the blazers and ties. Layer darker shadows over the base colors and gradients.

For shiny surfaces, such as hair, follow the contours of the subjects and use more shading to increase contrast.

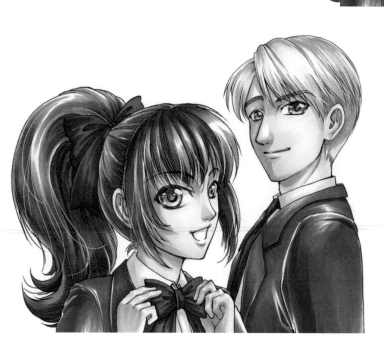

Use white ink to dot in small, shiny highlights and draw loose strands of hair over darker areas.

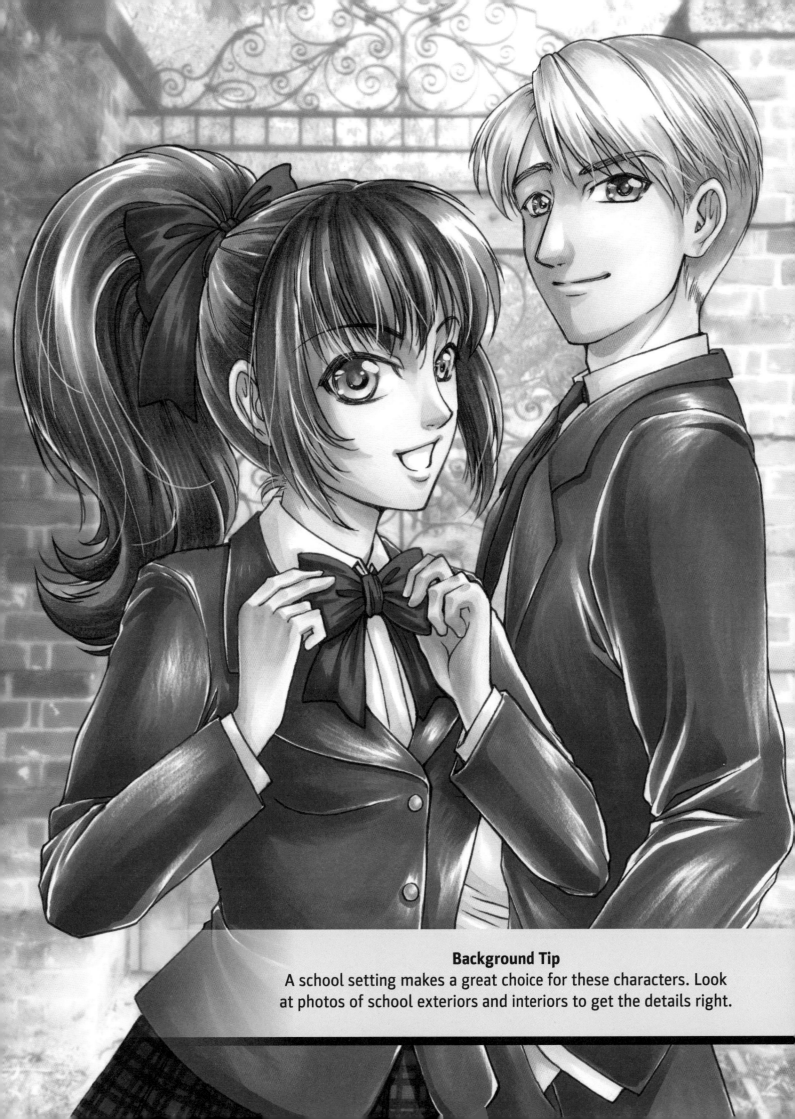

Background Tip
A school setting makes a great choice for these characters. Look
at photos of school exteriors and interiors to get the details right.

MAGICAL GIRL

BRAVE, BEAUTIFUL, AND BOLD, THE MAGICAL GIRL IS THE ULTIMATE MANGA HEROINE. MOST OF THE TIME, SHE LOOKS LIKE A NORMAL GIRL, BUT WHEN SOMEONE NEEDS HELP, SHE TRANSFORMS INTO A SPARKLY SUPERHERO AND SAVES THE DAY!

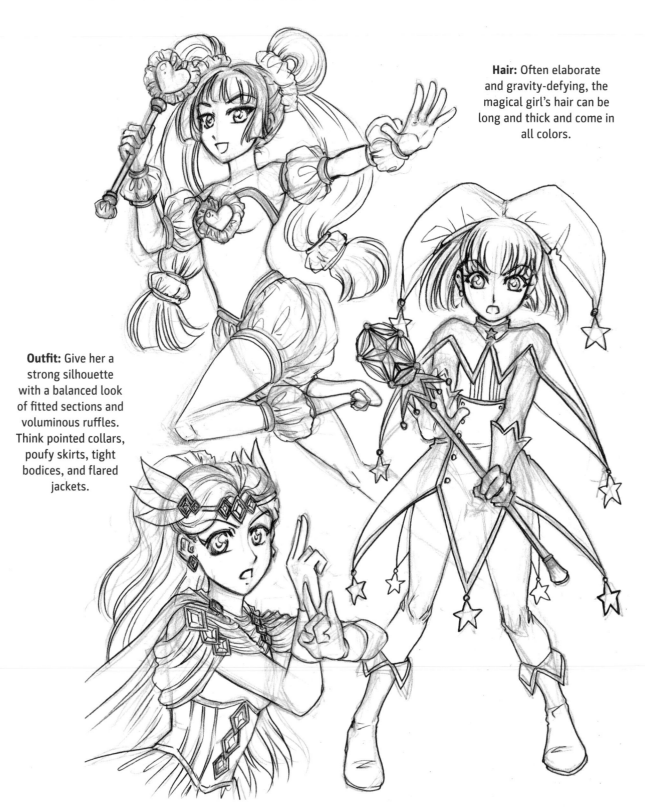

Hair: Often elaborate and gravity-defying, the magical girl's hair can be long and thick and come in all colors.

Outfit: Give her a strong silhouette with a balanced look of fitted sections and voluminous ruffles. Think pointed collars, poufy skirts, tight bodices, and flared jackets.

Accessories: The cuter, the better! Tiaras, ribbons, gloves, capes, bracelets, necklaces, chokers... decorate her to the max!

Gestures: To perform magical attacks, this character might use a magic wand, sword, bow and arrow, or even special hand gestures.

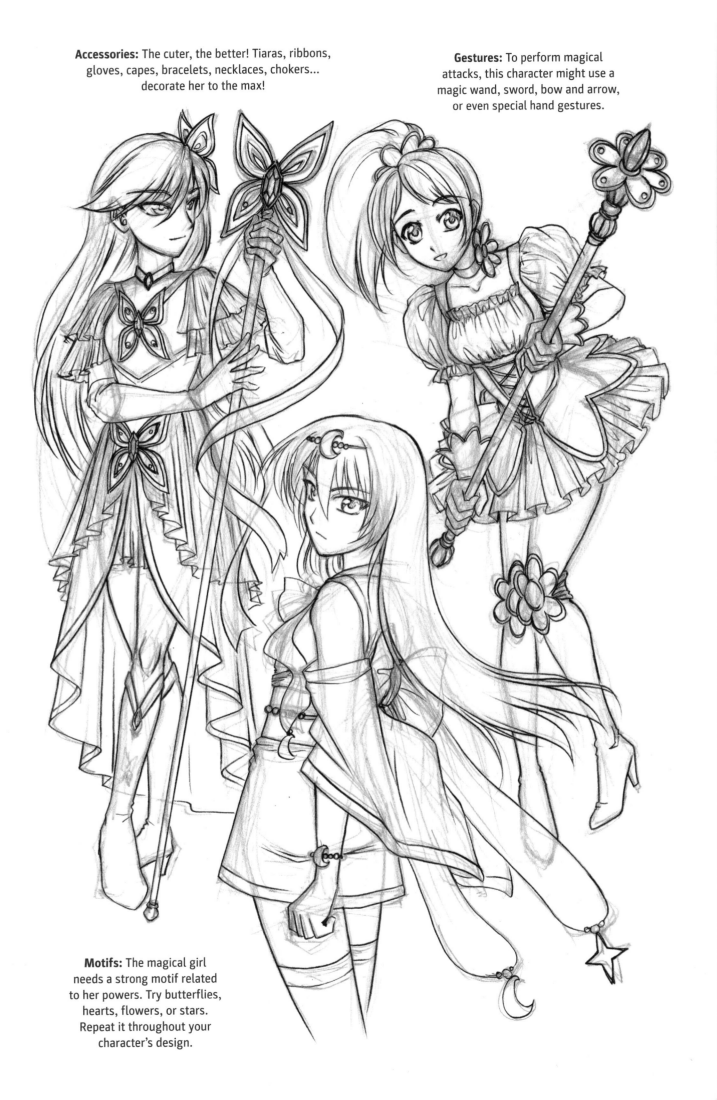

Motifs: The magical girl needs a strong motif related to her powers. Try butterflies, hearts, flowers, or stars. Repeat it throughout your character's design.

CHARACTER SHOWCASE: ANGEL THE MAGICAL GIRL

When Angela the Schoolgirl (page 18) hears a cry for help, she transforms into Angel, defender of love and justice! Her hair turns pink and curly, and her outfit features hints of her school colors. She carries a heart-shaped wand with a jewel that matches her eyes so that she can defeat her enemies and change their ways through the power of love.

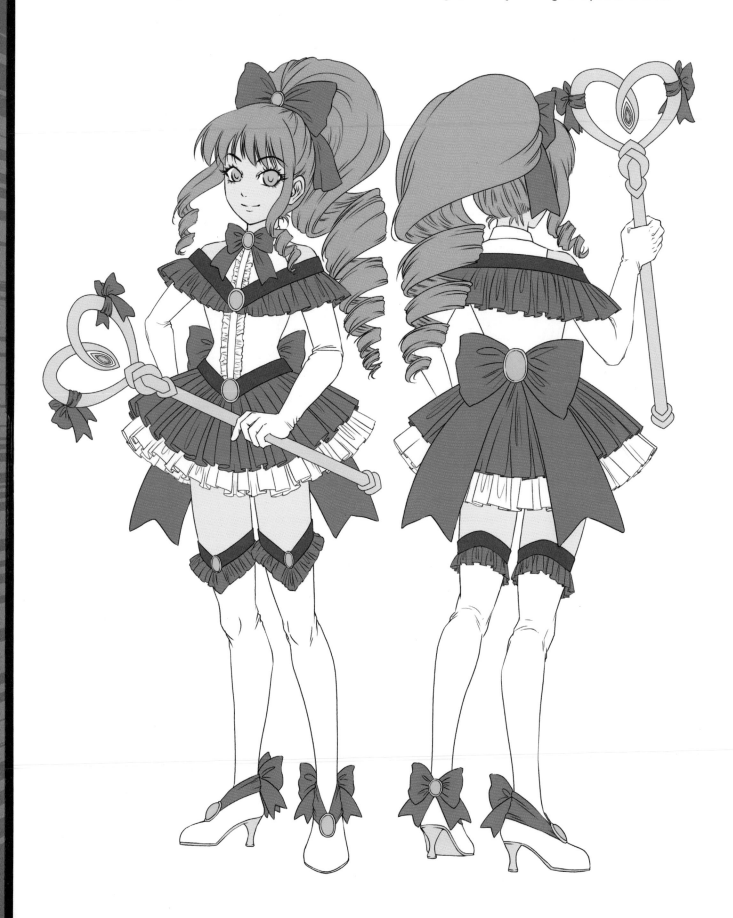

PRACTICE HERE!

Design your own magical girl. What's her name and special power? What does she look like?

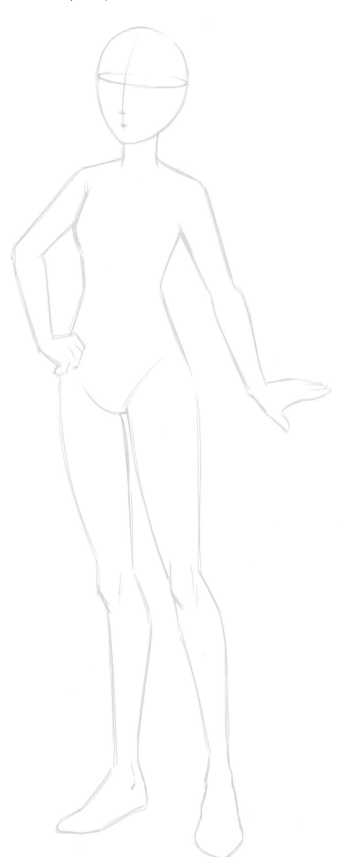

Many magical girls carry a wand.
Use this grid to design one.

STEP-BY-STEP: MAGICAL GIRL

JUST LIKE TRADITIONAL ART MEDIA, SUCH AS COLORED PENCILS AND MARKERS, DIGITAL TOOLS CAN BE USED TO ADD COLOR TO YOUR MANGA ARTWORK.

I sketched my figure using mechanical pencil; then I scanned and colored it in digitally.

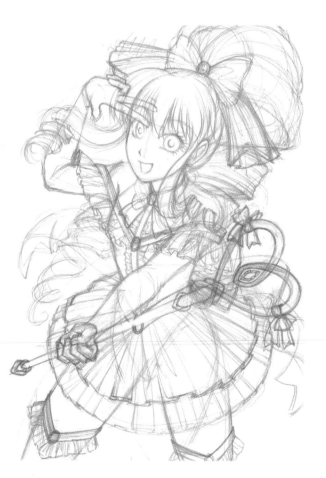

Use red pencil to lay down the main lines of the body. Focus on getting the proportions right and capturing the energy of the pose.

With rough lines, add details to the character's face, clothing, hair, and wand. Change elements of the drawing now, such as leg positions, and add movement using flowing hair and ribbons.

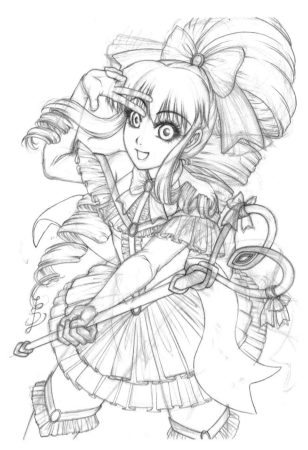

With black pencil, go back over your red pencil lines to create the final outlines.

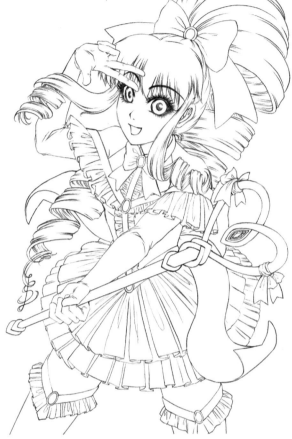

Photocopy and then scan your image. You can also scan the image and then adjust the color settings to remove the red lines.

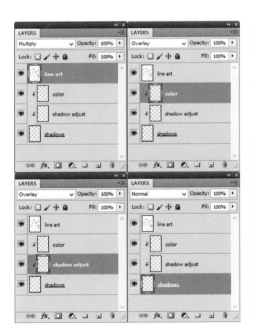

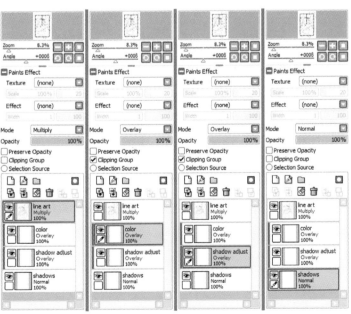

I've included examples using two kinds of software. To prepare your image for digital grisaille coloring (shading in gray and then tinting with color), set this line-art layer to "multiply." Then set it to "overlay" and add a layer underneath for colors, and another layer beneath it for shadow adjustment. Then add a layer at the bottom for shadows.

Set the color layer and shadow adjust layer to "clipping mask" or "clipping group" so that they affect only the shadow layer.

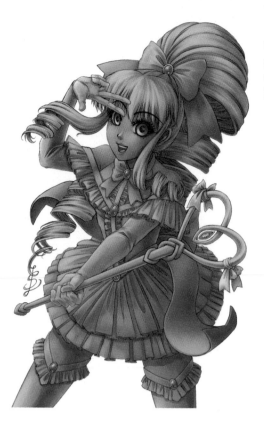

On the shadow layer, use a mid-gray fill. Shade gradually, using white shades for highlights and black ones for shadows.

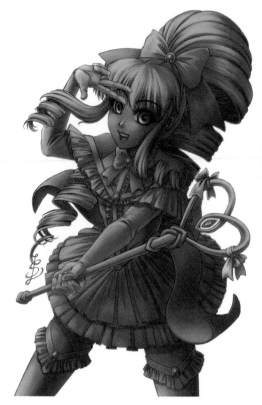

Fill in the shadow adjustment layer with reddish-brown to tint the shadows to a sepia shade.

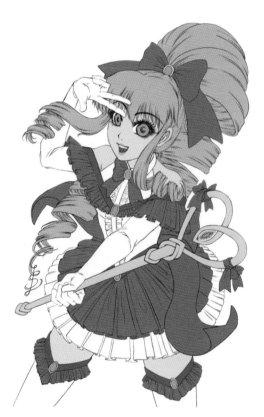

On the color layer, flat fill in the colors to tint the now-sepia shadows beneath. Switch the layer setting between "normal" and "overlay."

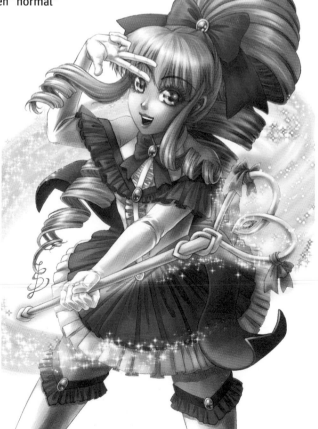

Add a final layer on top to create special effects like glowing, highlights, and sparkles.

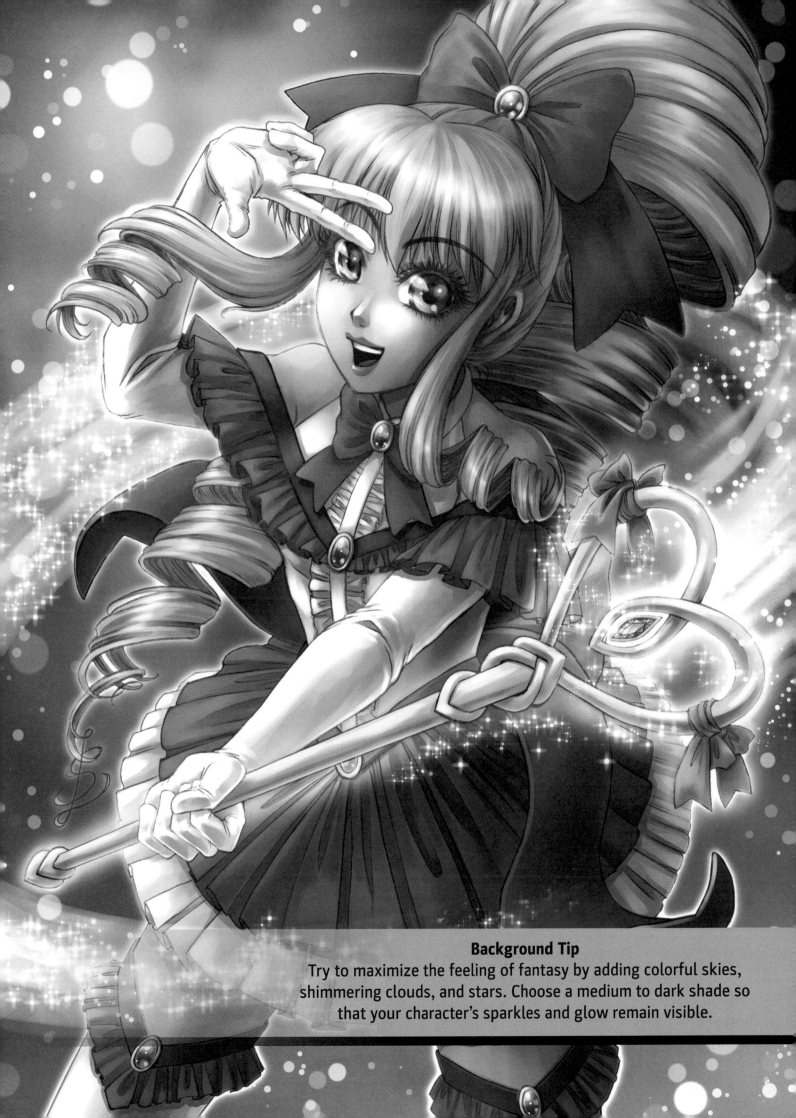

Background Tip
Try to maximize the feeling of fantasy by adding colorful skies, shimmering clouds, and stars. Choose a medium to dark shade so that your character's sparkles and glow remain visible.

OFFICE WORKER

THE MAIN PROTAGONISTS OF MANGA AIMED AT OLDER AUDIENCES, OFFICE EMPLOYEES WILL WORK A TYPICAL 9-TO-5 DAY, BUT THEIR TIME MAY BE DEVOTED TO DEALING WITH NONTRADITIONAL WORK PROBLEMS SUCH AS ZOMBIE ATTACKS. LET'S GET YOUR OFFICE WORKER CORRECTLY SUITED TO HANDLE ANYTHING!

Suit collars: Draw a Mandarin, peak, notched, or shawl-style lapel.

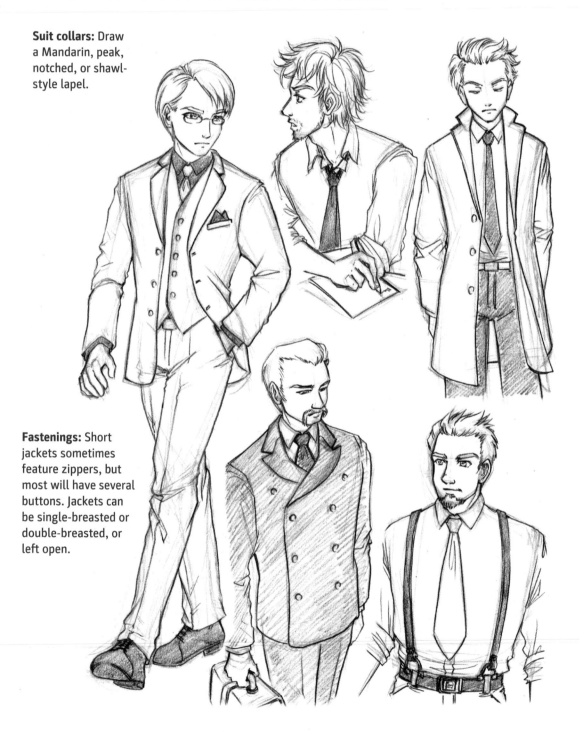

Fastenings: Short jackets sometimes feature zippers, but most will have several buttons. Jackets can be single-breasted or double-breasted, or left open.

Accessories: Aside from neckties, consider pocket squares, waistcoats, and suspenders for men. Scarves, fancy belts, and brooches are popular among women.

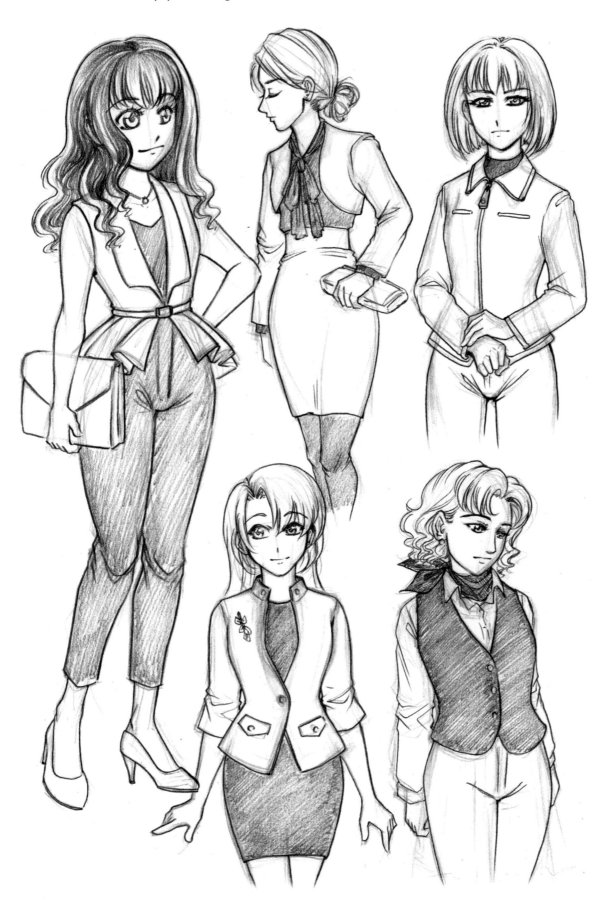

CHARACTER SHOWCASES: ZOFIYA & MATHIEU

Zofiya is the stern finance director at a software firm, while Mathieu is the laid-back marketing guru called in to boost profits. They are polar opposites, but sparks fly as they face off in the boardroom!

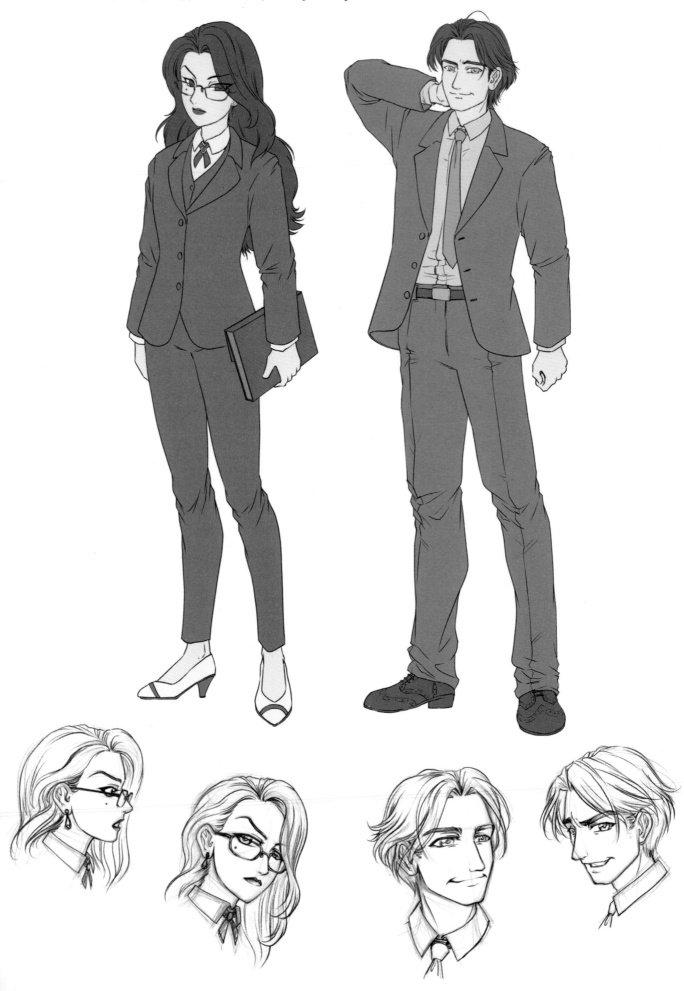

PRACTICE HERE!

Consider Zofiya and Mathieu's personalities, and then use these templates to practice drawing their facial expressions.

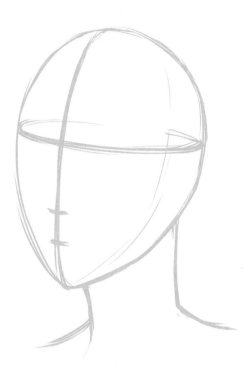

STEP-BY-STEP: OFFICE WORKERS

NOW LET'S LEARN TO DRAW ZOFIYA AND MATHIEU IN A SCENE TOGETHER!

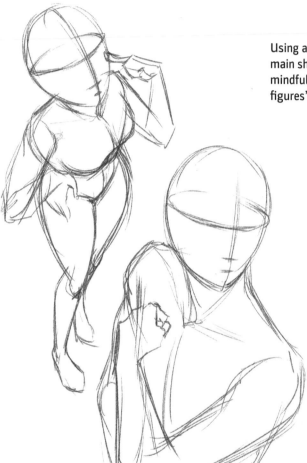

Using a pencil and paper, draw the main shapes of your characters. Be mindful of perspective, and use the figures' hands to emphasize it.

Fill in the details of the characters' clothing, hair, and faces. Add framing touches to the design, such as scattered sheets of paper fluttering around.

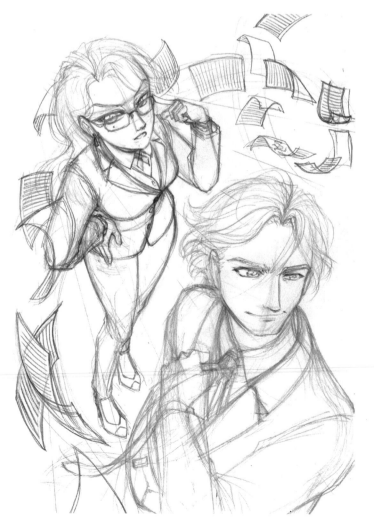

I used colored pencils on 90gsm tracing paper for this project.

Use darker shades of colored pencils on tracing paper to carefully trace your drawing. Avoid using black and gray if possible; instead; use browns for warm colors and dark blues for cool ones. This will create a more vibrant finish.

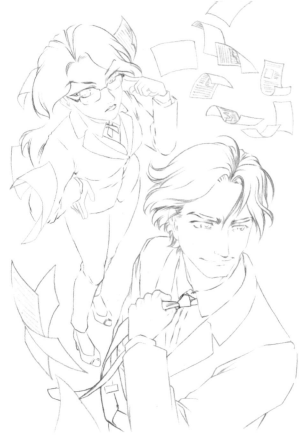

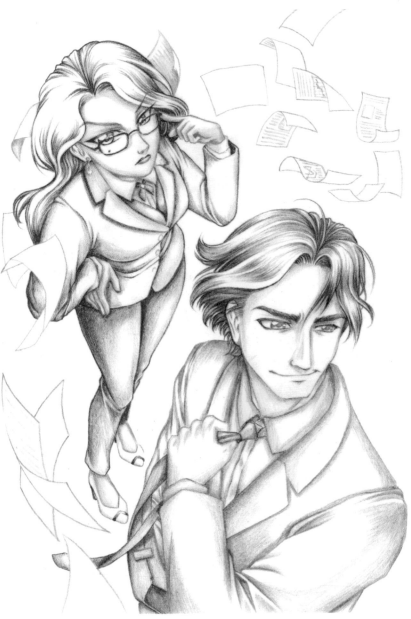

Begin shading the figures, starting with the darkest shadows in the outlines and leaving areas blank to create highlights and lighter shading. Use sharpened pencils to showcase strong, thin strokes on the figures' hair.

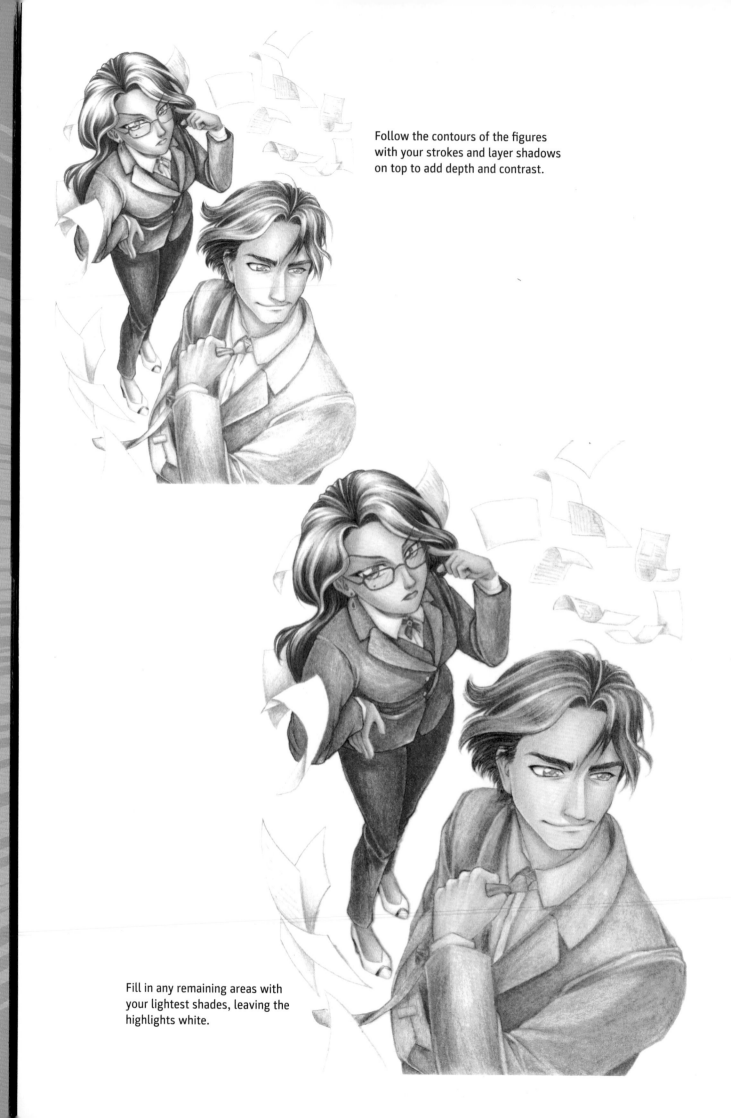

Follow the contours of the figures with your strokes and layer shadows on top to add depth and contrast.

Fill in any remaining areas with your lightest shades, leaving the highlights white.

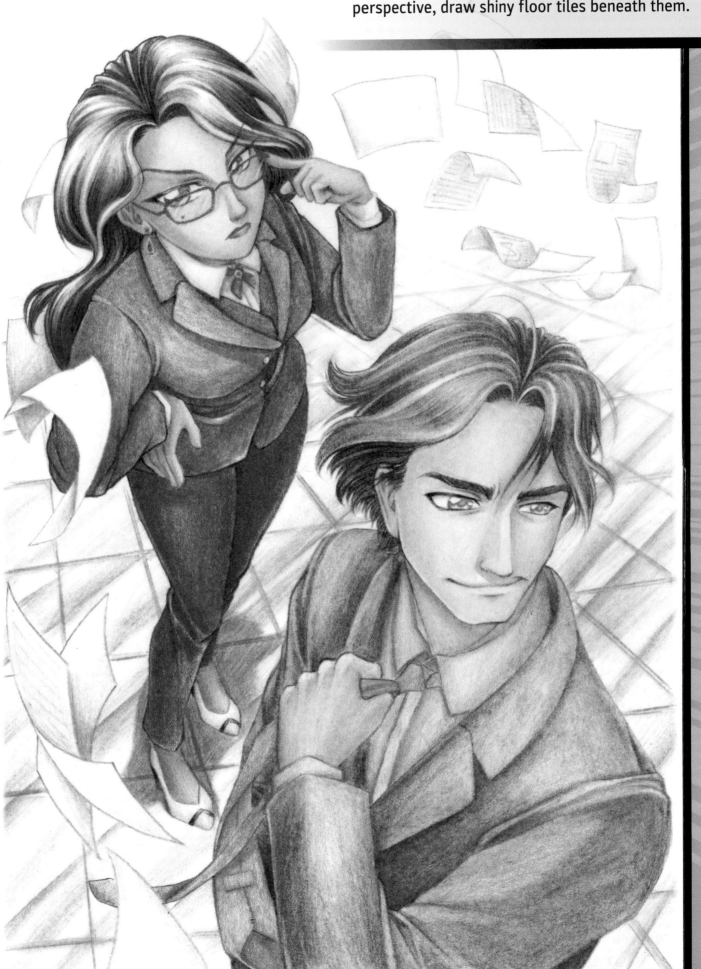

ELITE SOLDIER

ESSENTIAL CHARACTERS IN CONTEMPORARY ACTION MANGA, ELITE SOLDIERS CAN TAKE THE ROLE OF THE HERO OR SUPPORTING CHARACTER WHEN YOU NEED HEAVY FIREPOWER AND SOMEONE TO FIGHT THE BAD GUYS AND MONSTERS. THEY SHOULD LOOK CAPABLE, GRITTY, AND STRONG.

Insignia: Soldiers are part of specific units, and their uniforms might feature their coat of arms or insignia. Consider displaying one of these on their berets, arm patches, badges, or pins.

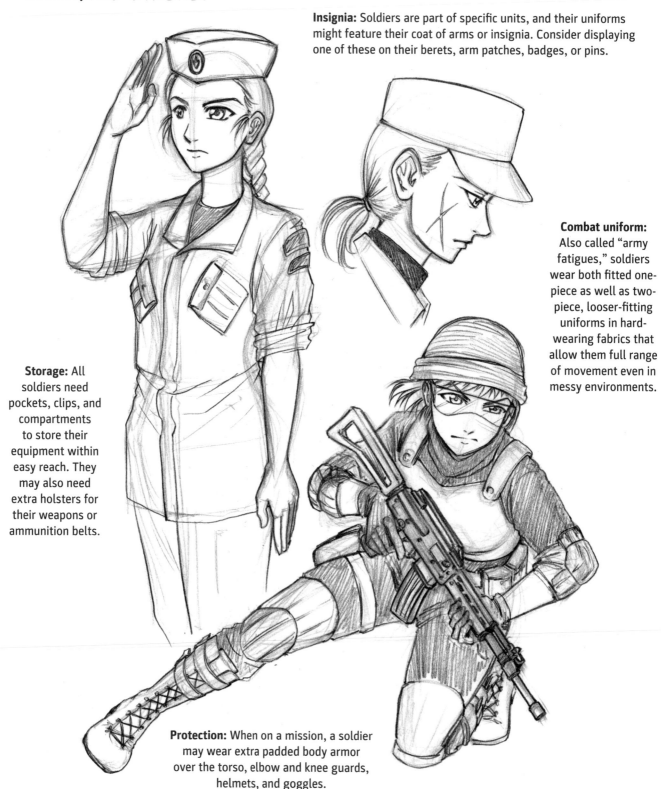

Combat uniform: Also called "army fatigues," soldiers wear both fitted one-piece as well as two-piece, looser-fitting uniforms in hard-wearing fabrics that allow them full range of movement even in messy environments.

Storage: All soldiers need pockets, clips, and compartments to store their equipment within easy reach. They may also need extra holsters for their weapons or ammunition belts.

Protection: When on a mission, a soldier may wear extra padded body armor over the torso, elbow and knee guards, helmets, and goggles.

CHARACTER SHOWCASES: ROXANNE & LOGAN

Roxanne is a seasoned veteran and cold-weather specialist. Quiet and determined, she focuses entirely on her objectives. She helped train Logan (page 44), who has matured from a brash, young man into a cautious, reflective officer.

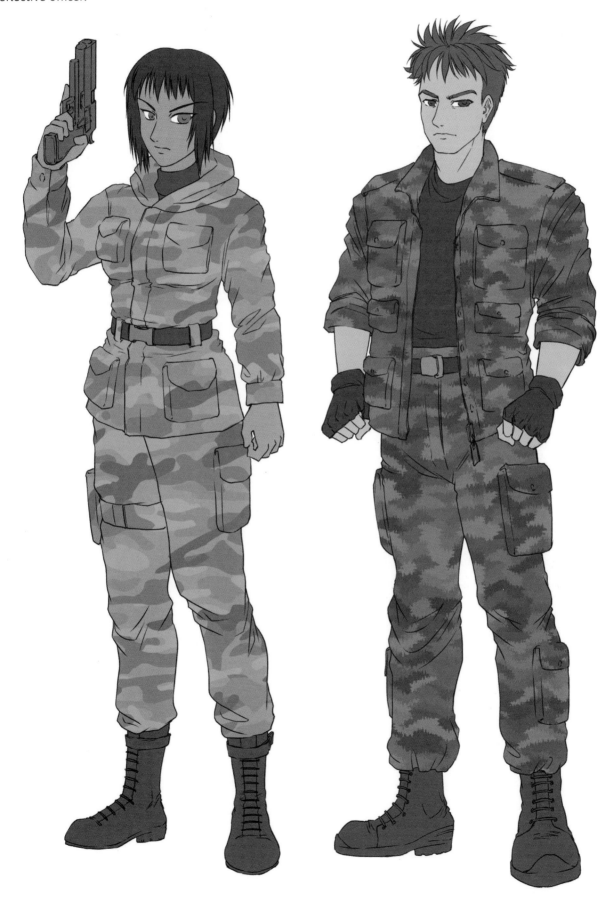

PRACTICE HERE!

Design a uniform and weapon for Logan using this character template. What would he wear when stationed in the desert? What kind of weapon would he carry?

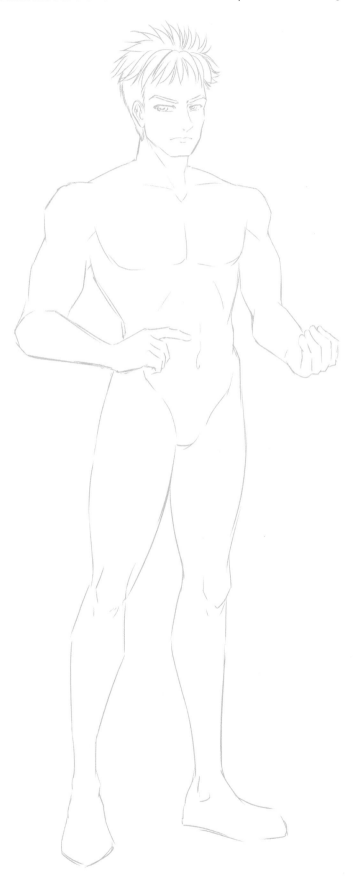

MARTIAL ARTIST

FOR A MODERN-DAY MANGA HERO OR HEROINE WHO CAN FIGHT, TRY CREATING A MARTIAL ARTIST. THERE ARE MANY STYLES OF MARTIAL ART AROUND THE WORLD, BUT WE'LL FOCUS ON THE ONES FROM JAPAN.

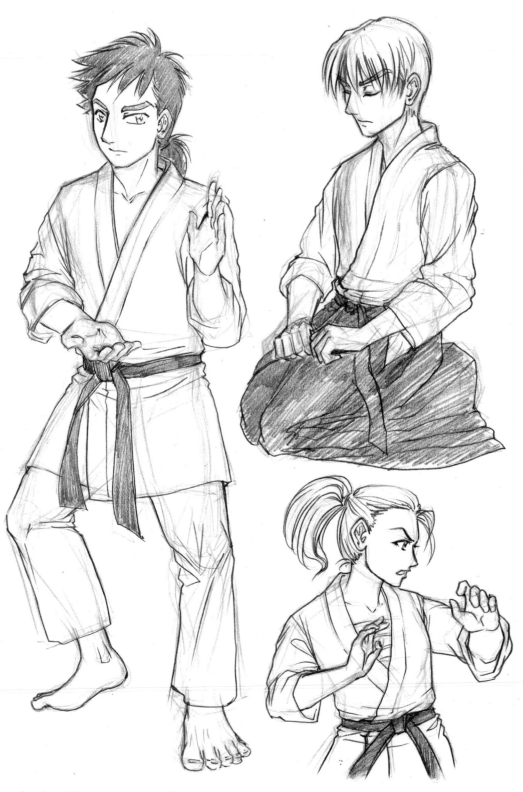

Hand-to-hand: Karate, judo, and aikido emphasize unarmed combat, and practitioners wear clothing that allows for free range of movement. The *gi* uniform consists of a wrap-style top worn with pants and a belt. Experienced practitioners wear long culottes or *hakama*.

Swords: *Kendo, iaido,* and *itto-ryu* all involve Japanese swords. In practice, students use a slim, wooden *bokken* or a thick bamboo *shinai*. The iconic sword with the curved blade is called a *katana*.

Clothing: Practitioners generally wear *hakama* with wrap-style tops. To spar, practitioners wear full armor or *bogu* (training armor).

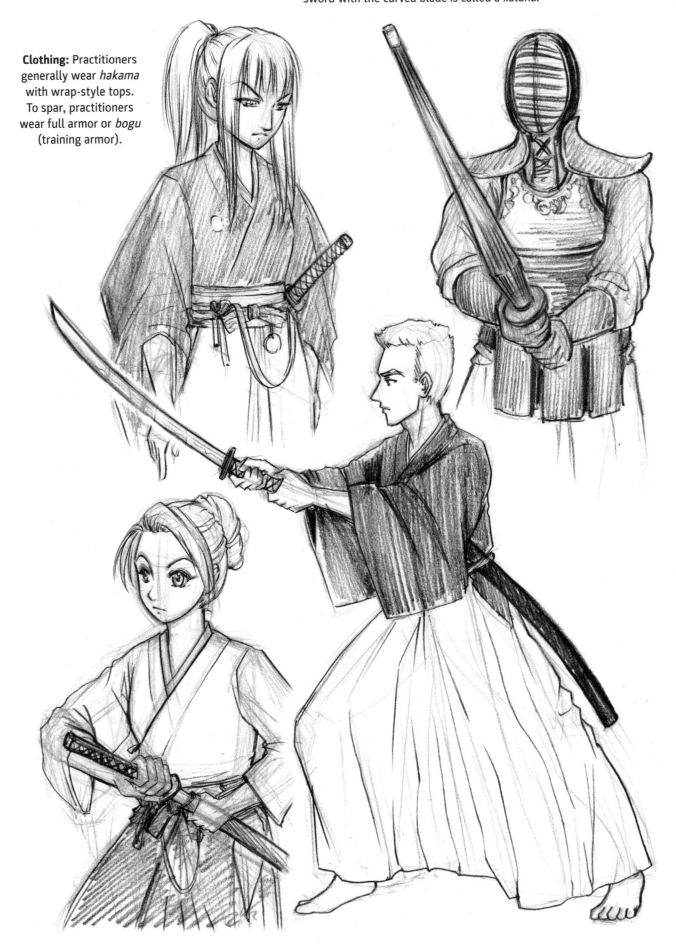

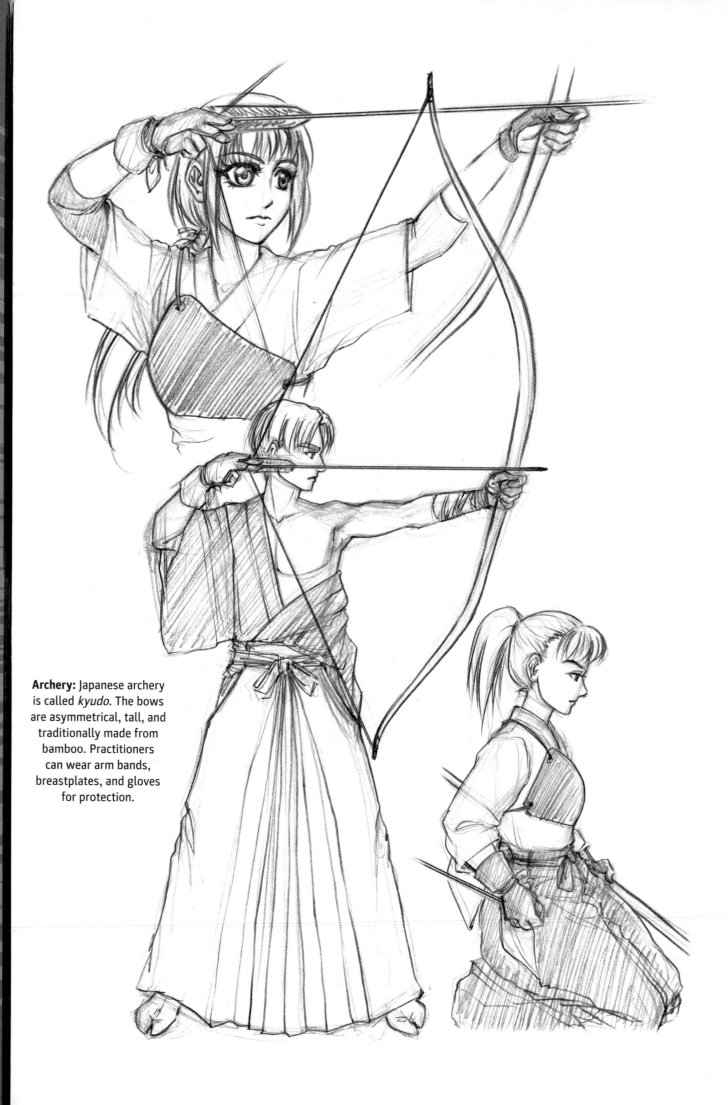

Archery: Japanese archery is called *kyudo*. The bows are asymmetrical, tall, and traditionally made from bamboo. Practitioners can wear arm bands, breastplates, and gloves for protection.

Stealth arts: *Ninjutsu* is the fighting system of the Japanese shadow warrior, the *ninja* or *shinobi*. Traditionally war spies, their style is efficient, quiet, and resourceful, and they wear practical clothing to allow for movement and quick getaways. They use multiple weapons, most famously *shuriken* (a small concealed dagger) and throwing stars.

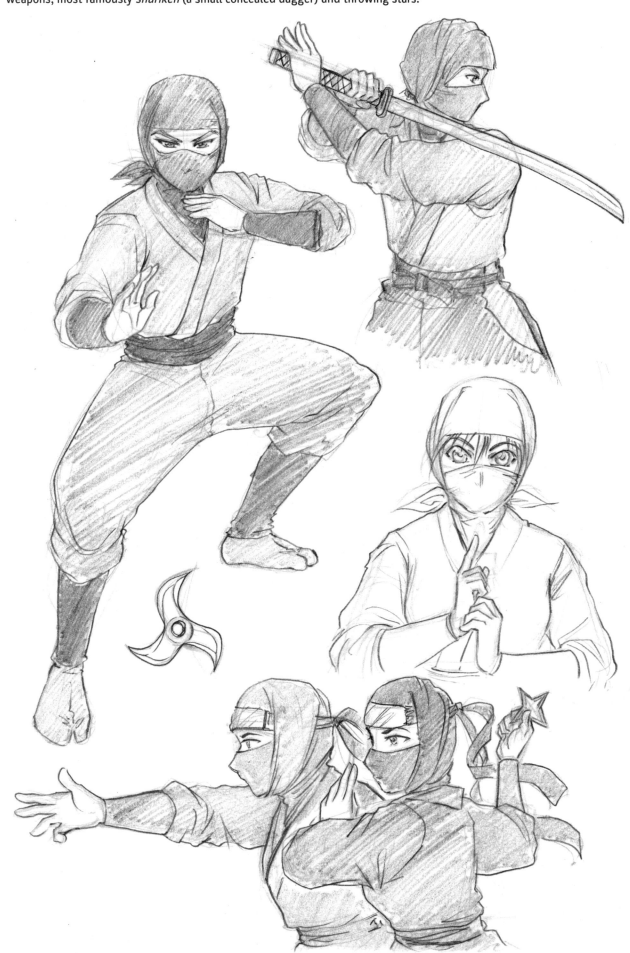

PRACTICE HERE!

Design a ninja's throwing star! Keep in mind that throwing stars can have three or more points, and their lines may be straight or curved. Here are some templates to help you design your own throwing stars.

Schools or dojos are popular locations for practicing martial arts, and they may have a logo or crest associated with them. Student uniforms often display a round crest. Try designing one now using flowers and birds as inspiration.

PRACTICE HERE!

Practice drawing various martial art poses using these stick figures. It's important to know how to sketch out figures dynamically while also correctly fleshing out a body over them. Try drawing over these stick figures, and then create your own!

FAIRY

BEAUTIFUL, FLUTTERY BEINGS OF FANTASY, FAIRIES ARE MAGICAL CREATURES WITH WINGS AND POINTED EARS. THEY COMMUNE WITH THE FOREST AND OFTEN HAVE MISCHIEVOUS, CHANGEABLE PERSONALITIES.

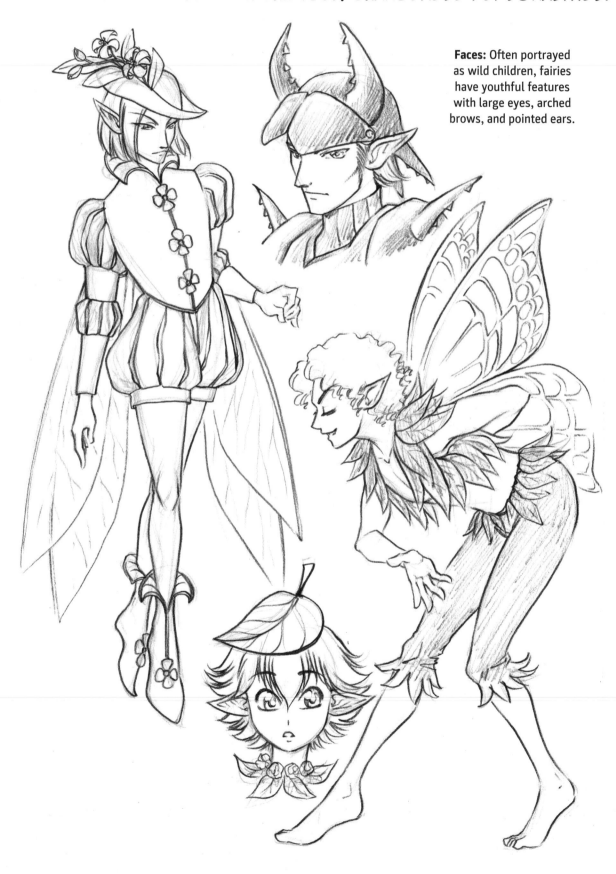

Faces: Often portrayed as wild children, fairies have youthful features with large eyes, arched brows, and pointed ears.

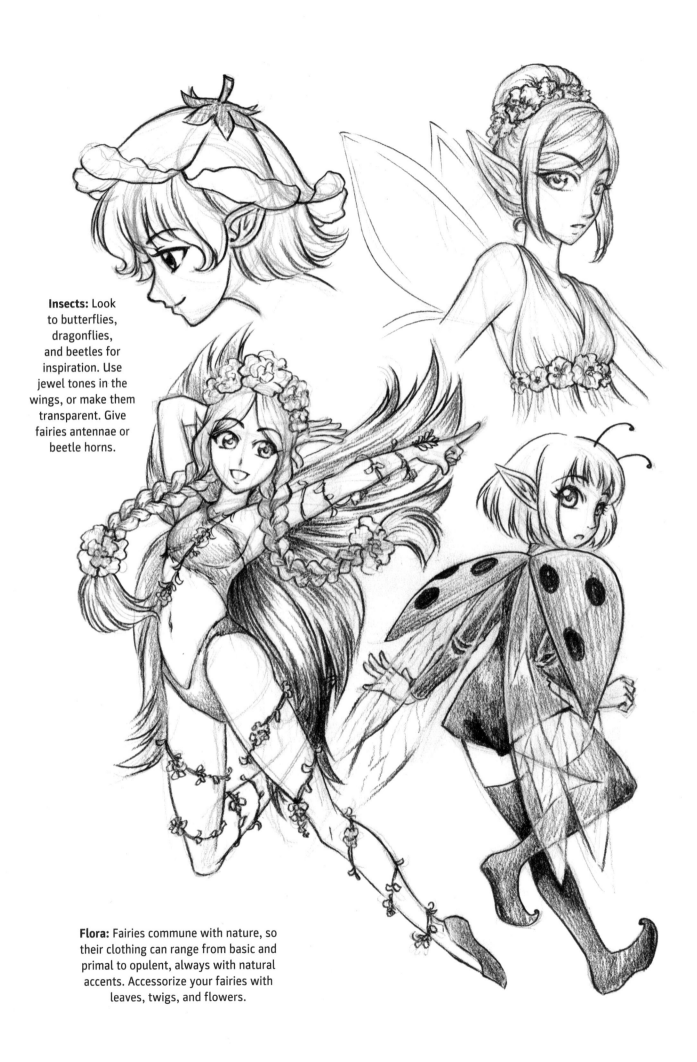

Insects: Look to butterflies, dragonflies, and beetles for inspiration. Use jewel tones in the wings, or make them transparent. Give fairies antennae or beetle horns.

Flora: Fairies commune with nature, so their clothing can range from basic and primal to opulent, always with natural accents. Accessorize your fairies with leaves, twigs, and flowers.

CHARACTER SHOWCASE: FAIRY QUEEN MAEVE

Elegant and exquisite, Fairy Queen Maeve's delicate appearance belies her cunning nature. Commander of an army of fairies, she has powerful magic and casts illusions to trick her enemies. She grants wishes to the worthy and punishes those who deserve it.

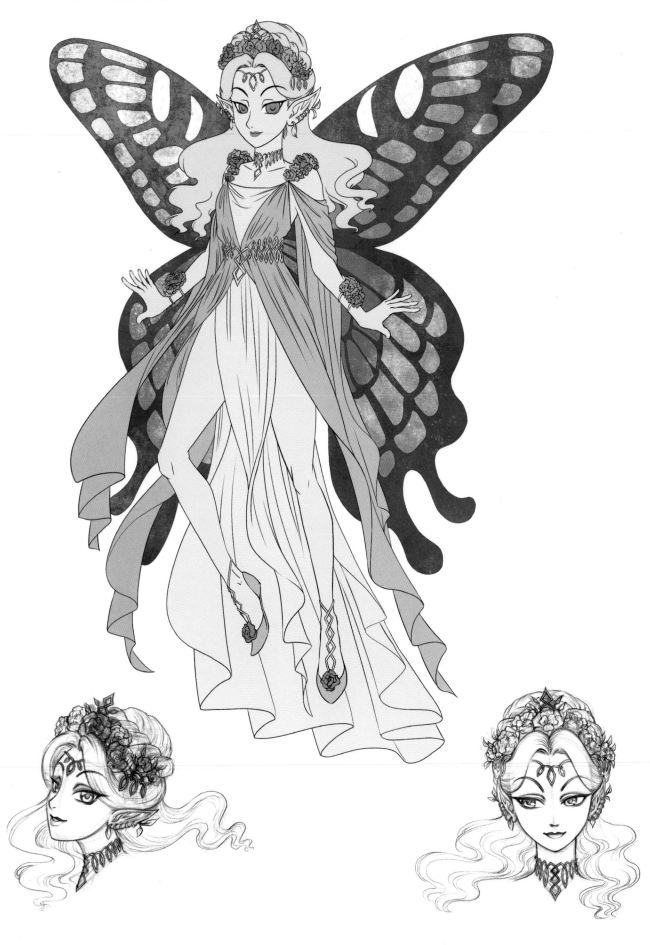

PRACTICE HERE!

Maeve can change the look of her wings at will. Try giving her another set!

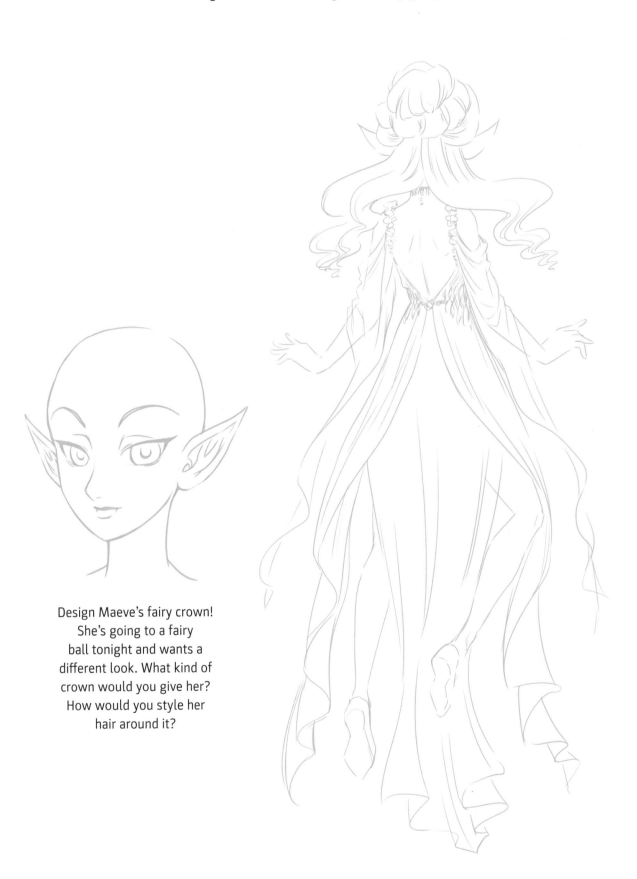

Design Maeve's fairy crown!
She's going to a fairy
ball tonight and wants a
different look. What kind of
crown would you give her?
How would you style her
hair around it?

STEP-BY-STEP: FAIRY QUEEN

COMPOSE A DRAWING THAT SHOWS OFF YOUR CHARACTER IN THE RIGHT SETTING. THINK CAREFULLY ABOUT THE FOREGROUND AND BACKGROUND ELEMENTS, AND ARRANGE THEM CORRECTLY.

I drew this fairy with mechanical pencils; then I scanned the image and colored it digitally.

Sketch the figure in red. Then neatly trace over your red lines using a black pencil. Scan the image and filter out the red, leaving only the black outlines.

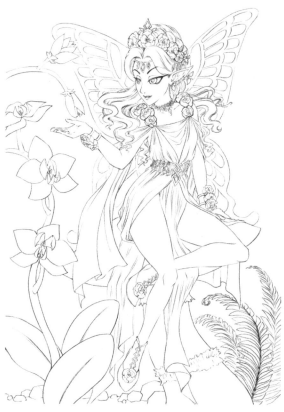

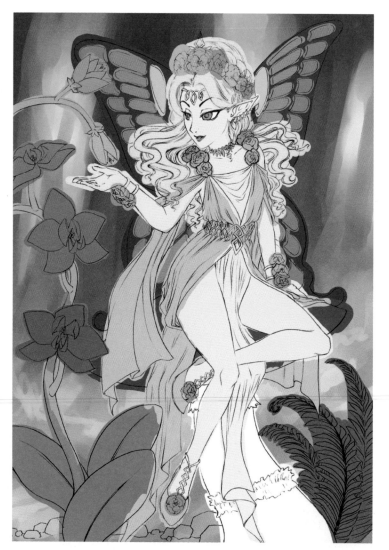

On a layer beneath the lines, roughly paint a background; then insert a layer in between to lay down some flat colors in the figure.

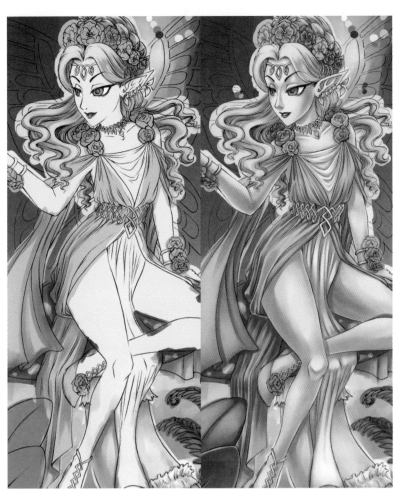

For a painterly look, do all of the character's shading and blending on a single layer, starting with the farthest elements (like the toadstool and the fairy's hair) and gradually working your way forward.

Background Tip
When emulating traditional painting techniques, it's best to plan the background first, as its colors should be blended into the foreground to create a harmonious image.

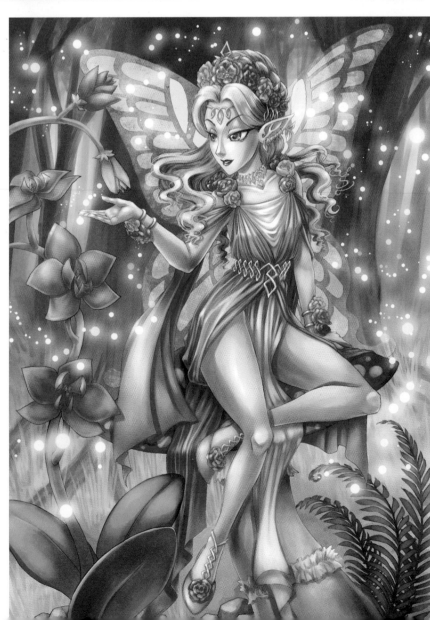

DWARF

DWARVES HAVE A REPUTATION FOR BEING EARTHY, NO-NONSENSE, STURDY FOLK. SHORT IN STATURE BUT STRONG, THEY WORK HARD AND LOVE ALL THINGS THAT GLITTER.

Build: Dwarves are shorter and stockier than most humans, so make sure to decrease their head-to-body ratio accordingly. Create square shapes with broad shoulders and hips to indicate their strength.

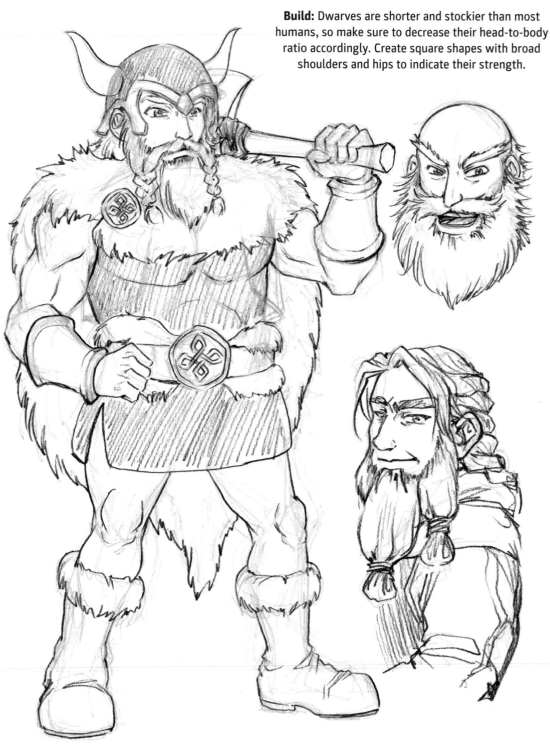

Motifs: Take inspiration from old Norse and Celtic designs: animal furs and horns, jewelry that features knots and patterns, woven cloth, chunky metal rings and coins, and rough gemstones.

Hair: Dwarves are famous for having thick, bushy hair everywhere. Add beards, sideburns, mustaches, and long hair. Bring those locks under control by adding braids and wraps.

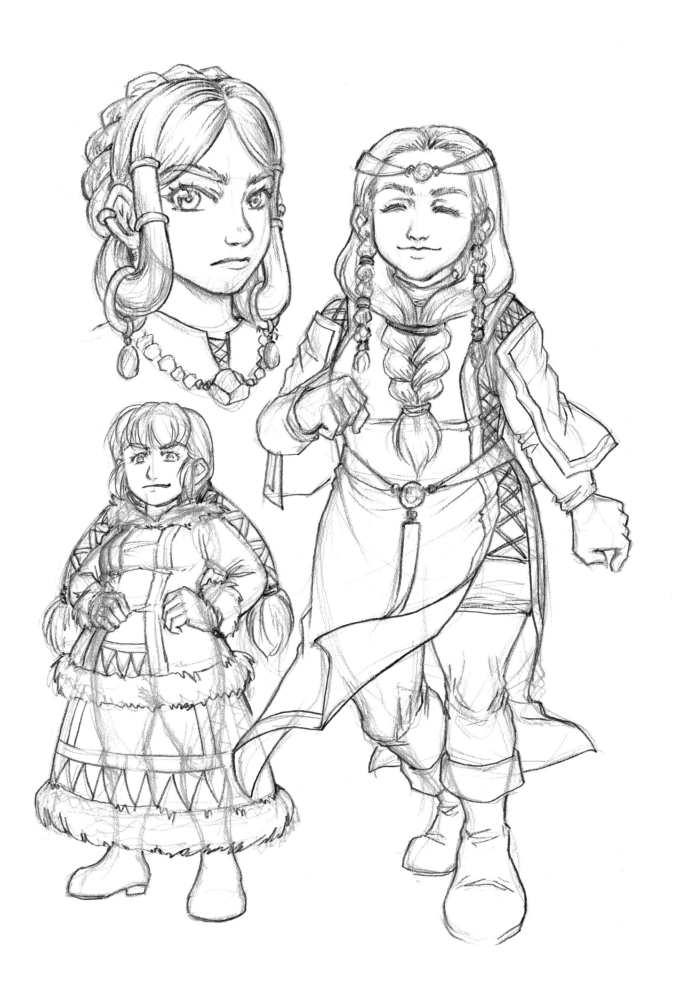

CHARACTER SHOWCASE: GOLDEMAR THE DWARVEN KING

Goldemar the Dwarven King is a mighty warrior, defending his homeland from invaders. His armor and hammer feature raw chunks of precious minerals. Although a fair and just king, he also likes to gamble, wagering gems on daredevil feats of bravery.

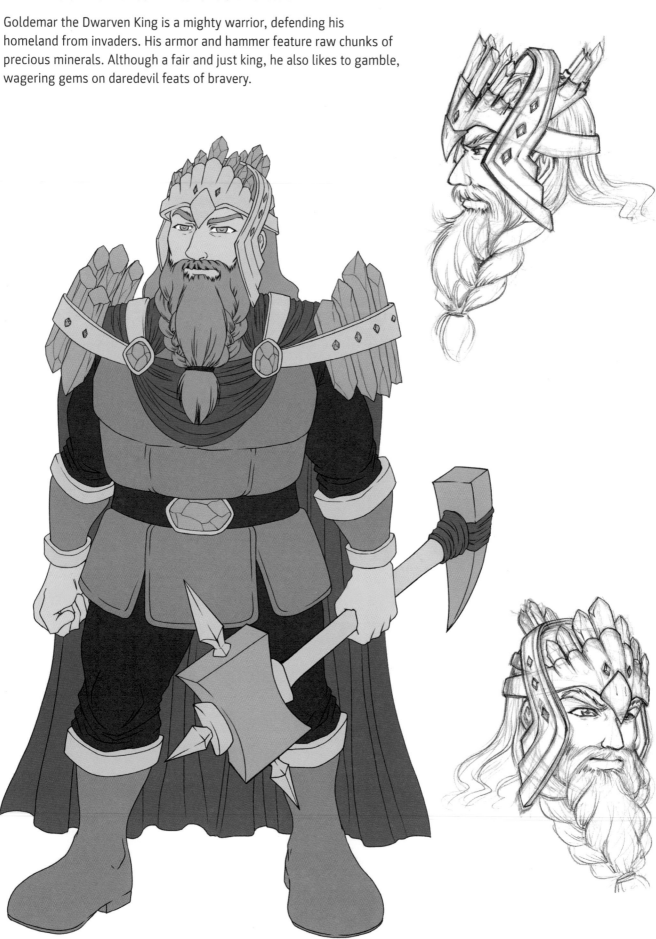

PRACTICE HERE!

Goldemar doesn't just use a hammer; he's also well-versed with an axe. Can you design one that's worthy of him?

KNIGHT

THE MAIN CHARACTERS OF MOST MEDIEVAL FANTASIES, GALLANT KNIGHTS IN THEIR SHINING ARMOR ARE KNOWN FOR THEIR HEROISM AND SENSE OF DUTY, PROTECTING THE WEAK, SLAYING BEASTS, AND UPHOLDING HONOR.

Armor: Armor should not restrict movement. Segment large pieces around the joints of the body, protecting vulnerable areas, such as the heart, as well as protruding body parts like elbows.

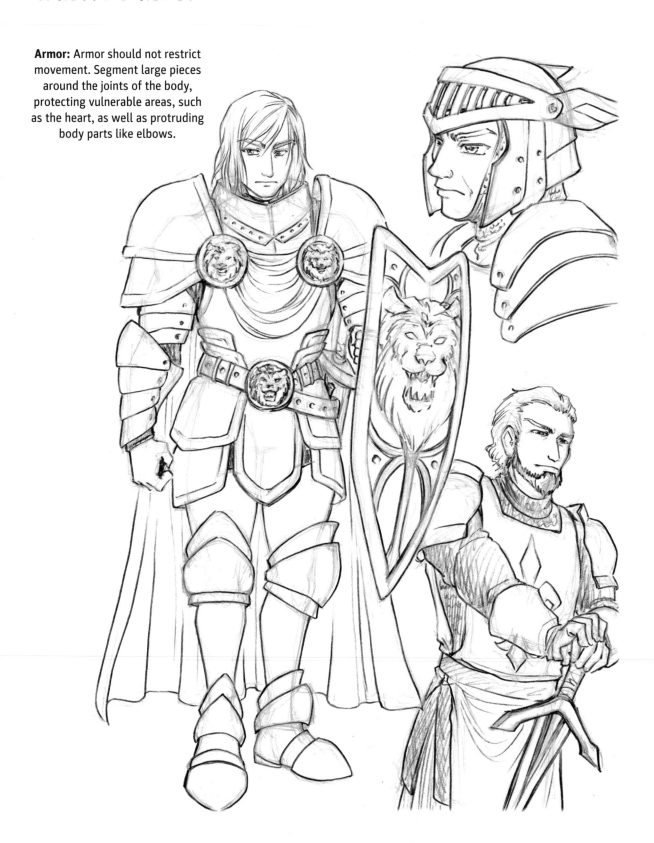

Weapons: Knights are heavily armored in order to attack and defend in close combat. They will often use large swords, spears, and maces, and many carry shields.

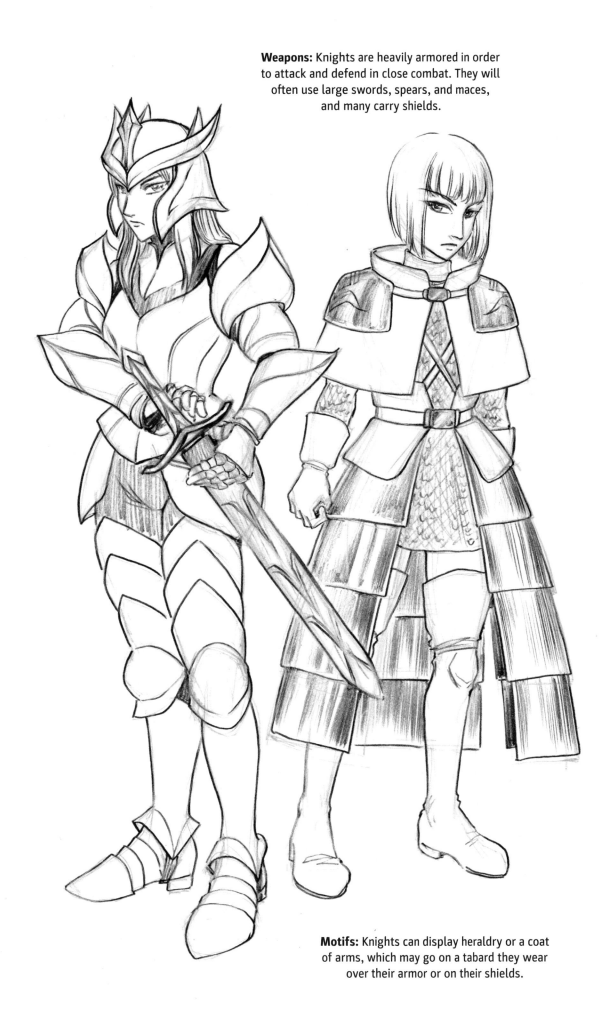

Motifs: Knights can display heraldry or a coat of arms, which may go on a tabard they wear over their armor or on their shields.

CHARACTER SHOWCASE: PRINCESS ELEANOR

Princess Eleanor refuses to sit by and let others fight her battles. She insists on training with her father's knights and has forged a reputation for herself as a skilled swordswoman.

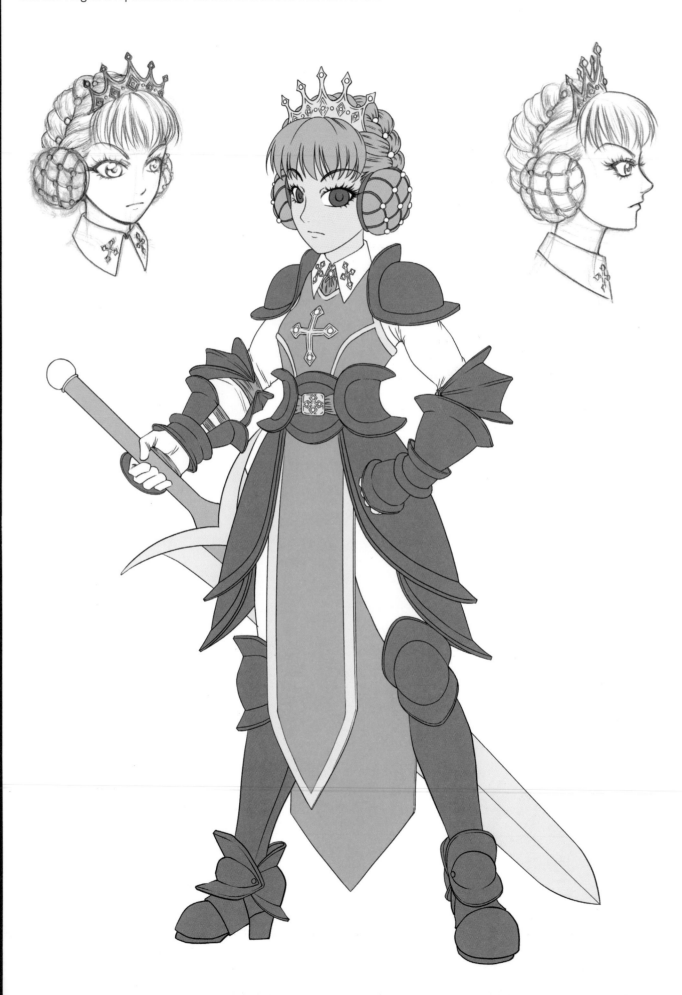

PRACTICE HERE!

Design Princess Eleanor's shield! She usually fights with a two-handed sword, but occasionally she'll switch to a short sword and shield. Think about its shape and which design motifs you want to incorporate.

STEP-BY-STEP: KNIGHT

VIEW TAPESTRIES AND OLD PAINTINGS FOR INSPIRATION WHEN DRAWING A KNIGHT.

I sketched and inked this image digitally; then I printed it and colored it in using markers and colored pencils.

Digitally sketch your main figure onto one layer and place the unicorn on another.

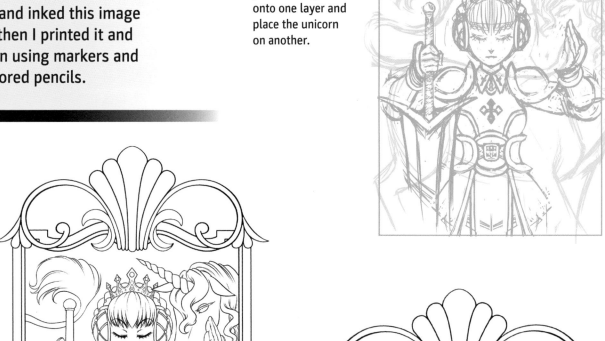

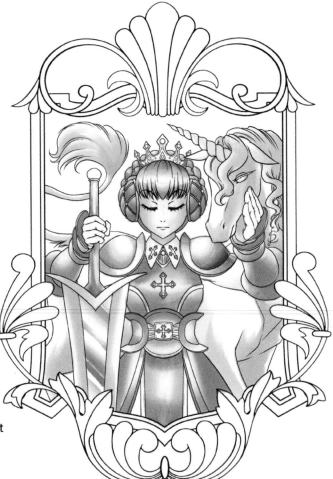

Neatly add ink over the sketch and design a frame around it, taking inspiration from ornate picture frames. Print a copy using a laser printer.

To add a calm, solemn mood to the image, incorporate soft lighting from above. Before working from light to dark, touch clear blender fluid to the colored tip of your marker to blend in gradient fills.

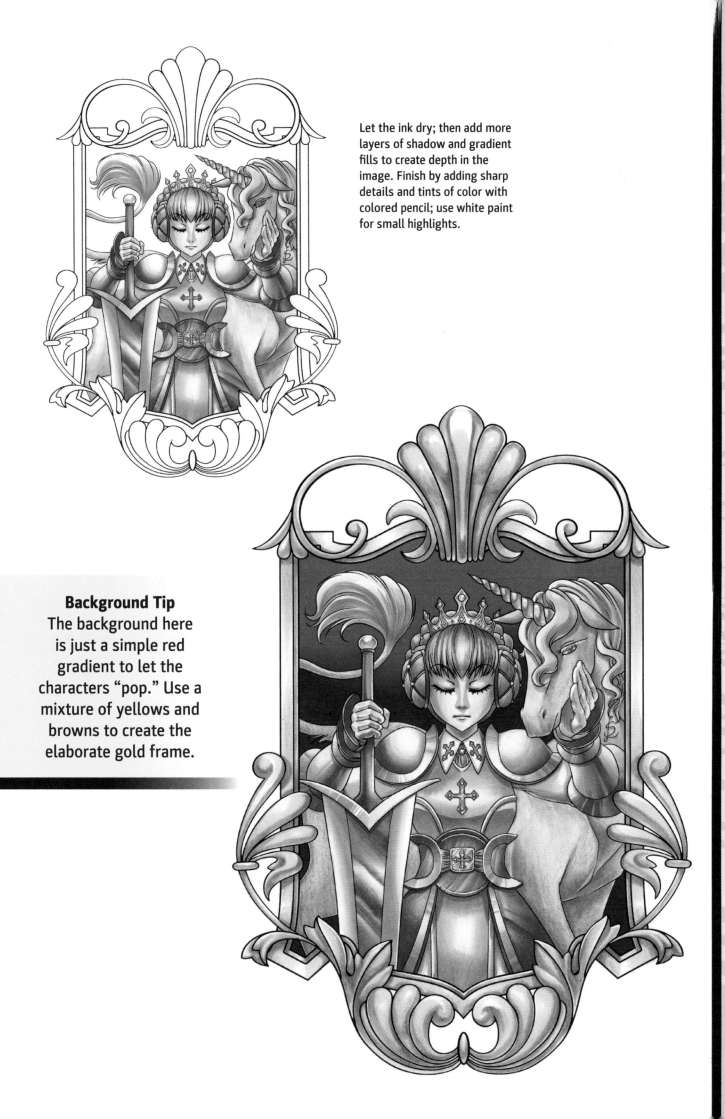

Let the ink dry; then add more layers of shadow and gradient fills to create depth in the image. Finish by adding sharp details and tints of color with colored pencil; use white paint for small highlights.

Background Tip
The background here is just a simple red gradient to let the characters "pop." Use a mixture of yellows and browns to create the elaborate gold frame.

BATTLE MAGE

MAGIC CASTERS WHO WIELD SPELLS AGAINST THEIR FOES, MAGES THROW FIREBALLS, BOLTS OF LIGHTNING, AND WATER SPOUTS.

Robes: Mages rely on magic to attack and defend and don't have to move quickly, so they tend to wear long robes or gowns with capes and hoods. They rarely carry weapons or wear heavy armor.

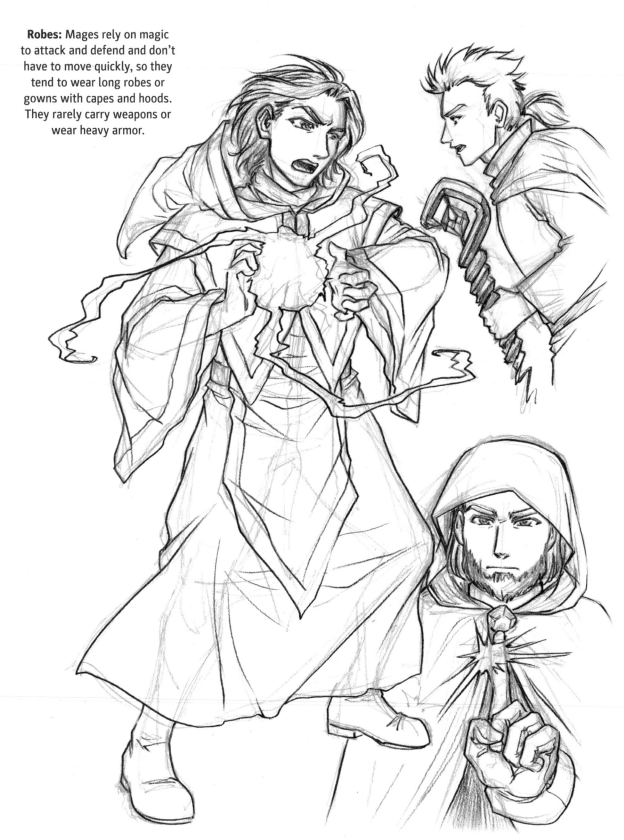

Accents: Mages may have magical symbols drawn on their clothing or equipment. Adorn them with patterns, sigils, talismans, gemstones, or jewelry.

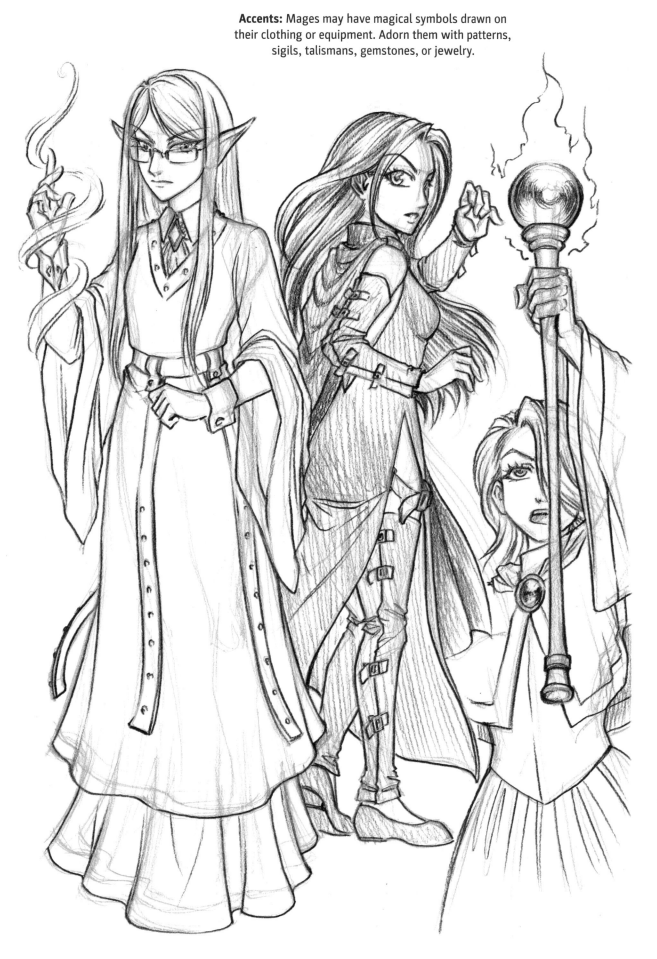

Spells: Think carefully about the shapes their spells might take, such as fluid curves for water, sharp spikes for lightning, and so on.

CHARACTER SHOWCASE: SILAS THE ELF MAGE

Silas is a young but powerful elf mage who likes to research spells around the world and add them to his grimoire. A kindhearted being who often encounters trouble during his travels, he uses magic to protect himself and others from harm.

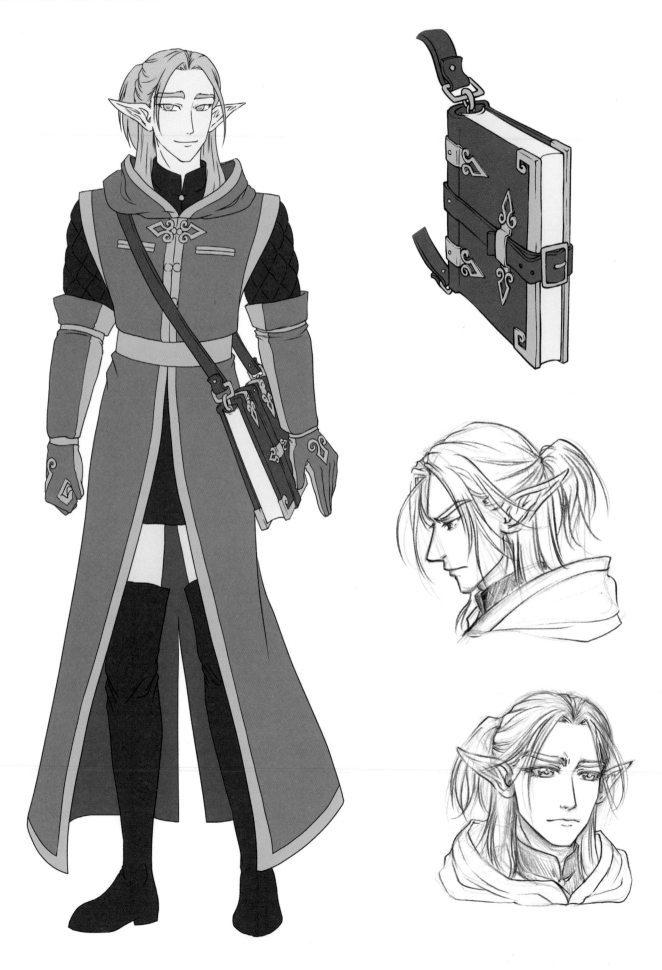

PRACTICE HERE!

Silas is casting a fireball spell! Draw it here as though it's forming around his arm.

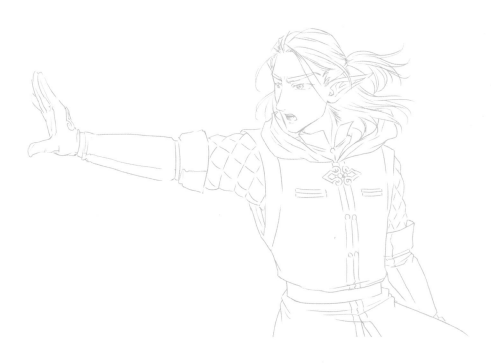

What would an icicle spell
look like? Draw it here!

STEP-BY-STEP: BATTLE MAGE

DRAW YOUR MAGE IN A POSE THAT CLEARLY SHOWS HIS HAND WITH A SPELL FORMING AROUND IT. HERE HE PULLS IN THREADS OF MAGIC TO MAKE A ROSE BLOOM, SHOWING HIS SOFTER SIDE.

I sketched, inked, and added color digitally.

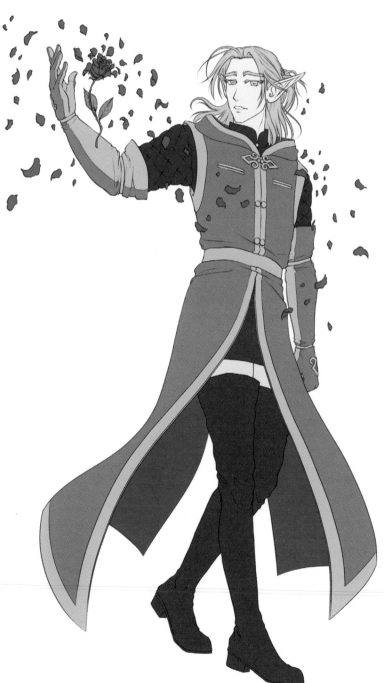

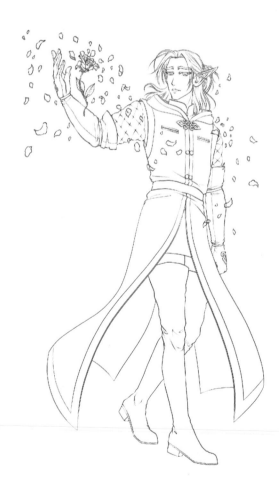

Sketch and then carefully add ink over your sketched lines. Use more than one layer for additional elements on top, like the rose and its petals. Then remove the sketch lines.

Add a layer beneath the lines and flat-fill in the midtone colors.

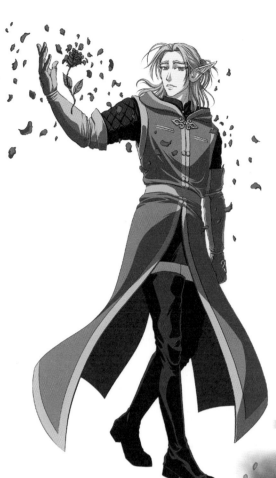

Add a layer beneath the lines and above the flat colors; then add sharp shadows, paying attention to the folds in the mage's clothing.

Background Tip
Aim for a stormy background with light radiating from the mage's hand and colorful tendrils to showcase the magic. Create highlights around the light source.

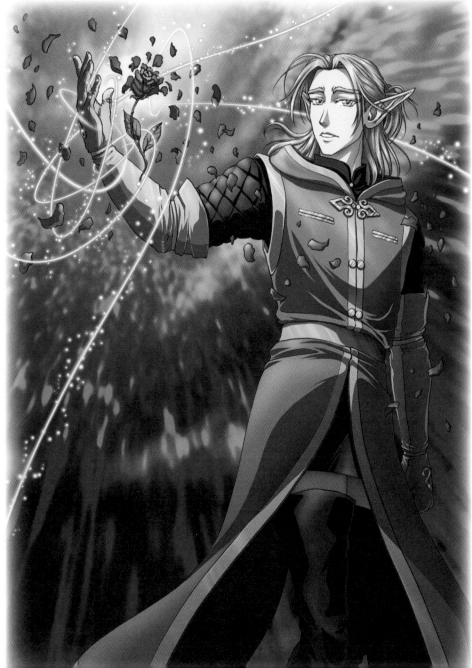

WITCH

FEARED AND REVERED THROUGHOUT HISTORY, WITCHES ARE A POPULAR CHARACTER TYPE IN FANTASY, CONTEMPORARY, AND HORROR MANGA STORIES. USUALLY WOMEN WITH MYSTICAL POWERS, THEY CAN TAKE DIFFERENT FORMS, DEPENDING ON THE STORY.

Headwear: Often, a witch wears a cone-shaped hat with a wide brim or a cloak with a large, pointed hood.

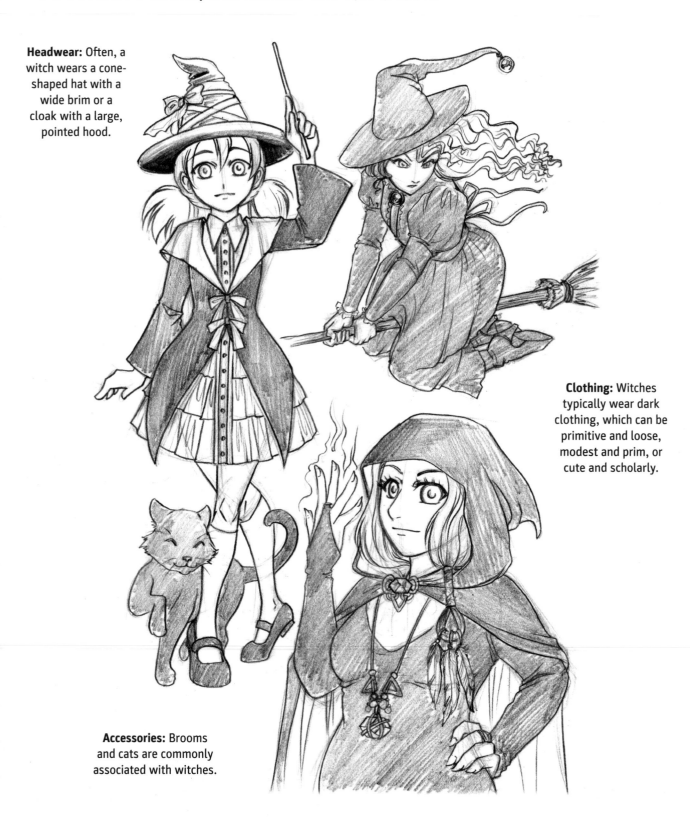

Clothing: Witches typically wear dark clothing, which can be primitive and loose, modest and prim, or cute and scholarly.

Accessories: Brooms and cats are commonly associated with witches.

CHARACTER SHOWCASE: BRAMBLE THE WITCH

Bramble the witch loves to sit in her garden, sleep in the sun, and tend the herbs and flowers used in her potions. Plants are drawn to her, especially the briar rose, which never wants to leave her alone!

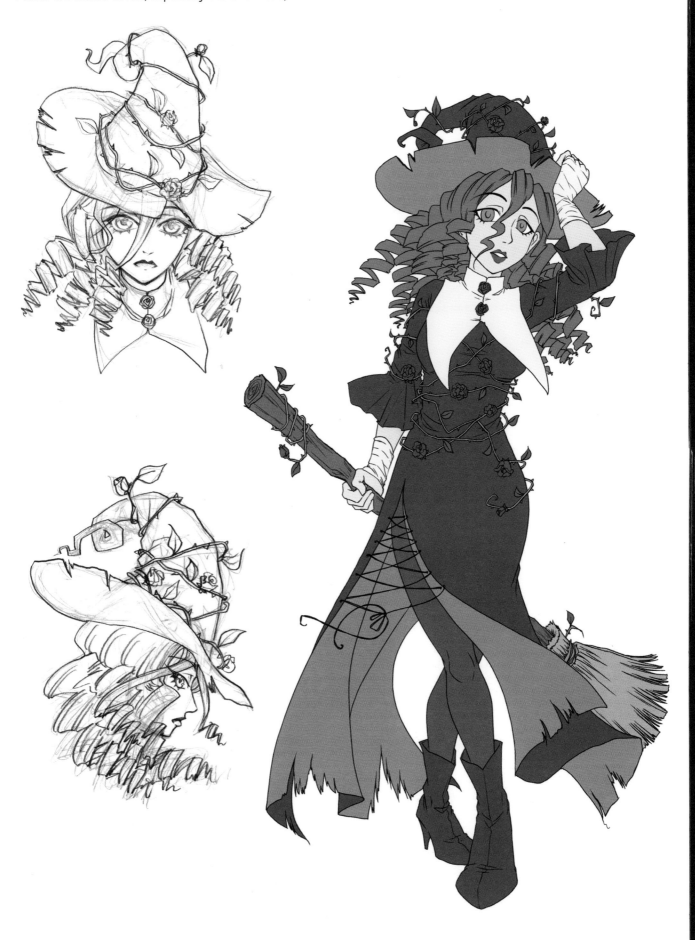

Bramble prefers to sit side-saddle
on her broom!

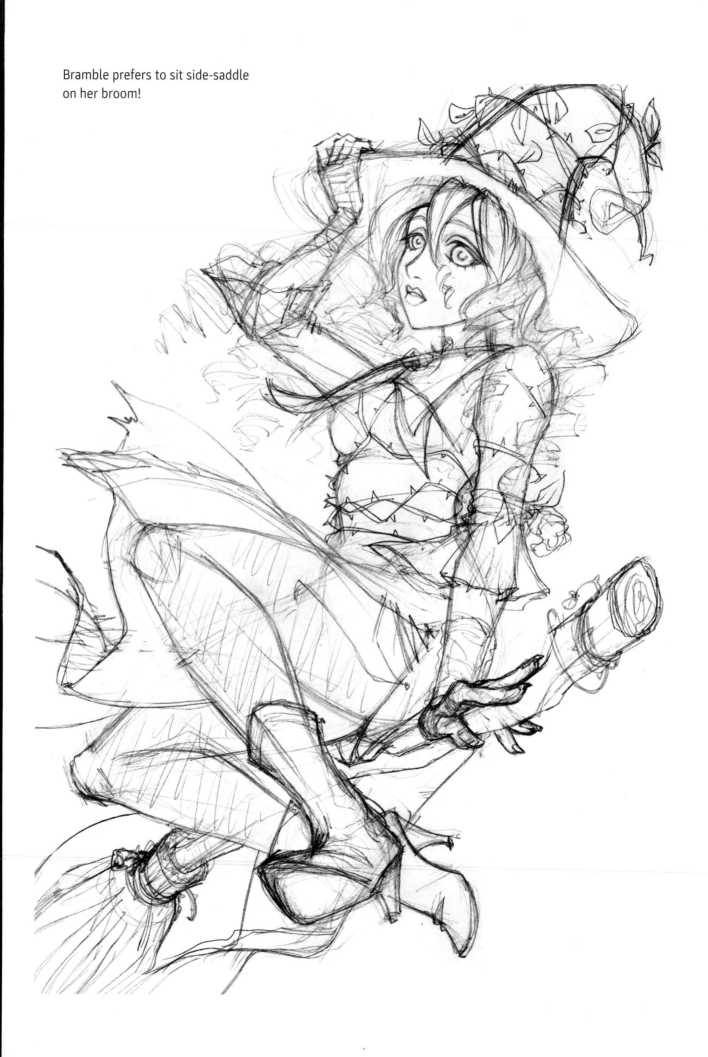

PRACTICE HERE!

Now try designing a witch's hat! Don't stick to the most common kind;
decorate it in a way that will make it stand out!

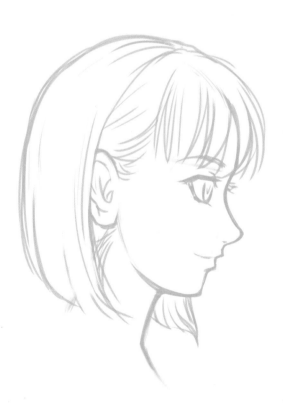

WARRIOR

YOU CAN'T CREATE A FANTASY SERIES WITHOUT CHARACTERS WHO CAN HOLD THEIR OWN DURING A BATTLE! THERE ARE MANY TYPES OF WARRIORS AND JUST AS MANY WEAPONS TO GO WITH THEIR VARIOUS STYLES OF ATTACK.

Clothing: Most warriors wear less armor than knights (pages 62-67), and they may show off lighter pieces as well, like leather jerkins or partial breastplates. Their clothing must match their fighting style.

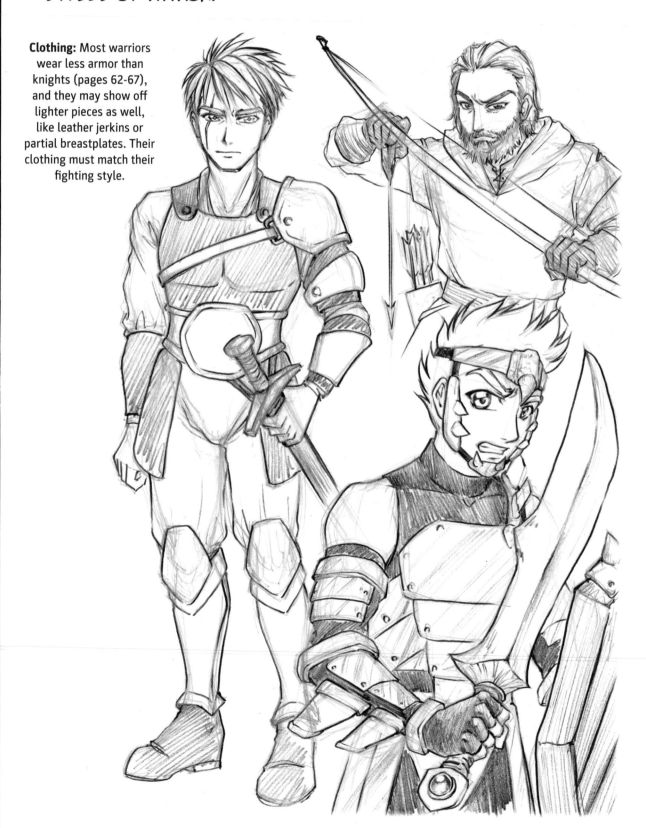

Specialties: Think of a specific occupation for the warrior you're drawing and try to tailor your character design for the job. Here are a few ideas to get you started: assassin, ranger, berserker, mercenary, rogue, or soldier.

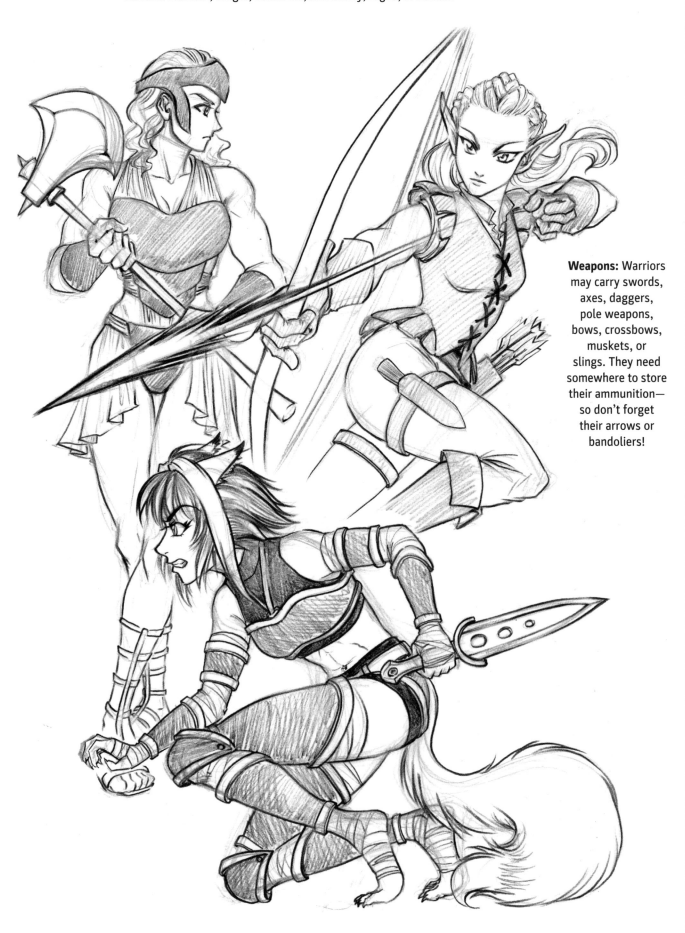

Weapons: Warriors may carry swords, axes, daggers, pole weapons, bows, crossbows, muskets, or slings. They need somewhere to store their ammunition— so don't forget their arrows or bandoliers!

CHARACTER SHOWCASE: KHAIDU

Young warrior Khaidu has something to prove. Wishing to earn a reputation within his tribe as a champion, he seeks to slay the most fearsome monsters in the land and bring back trophies as proof of his bravery and skill.

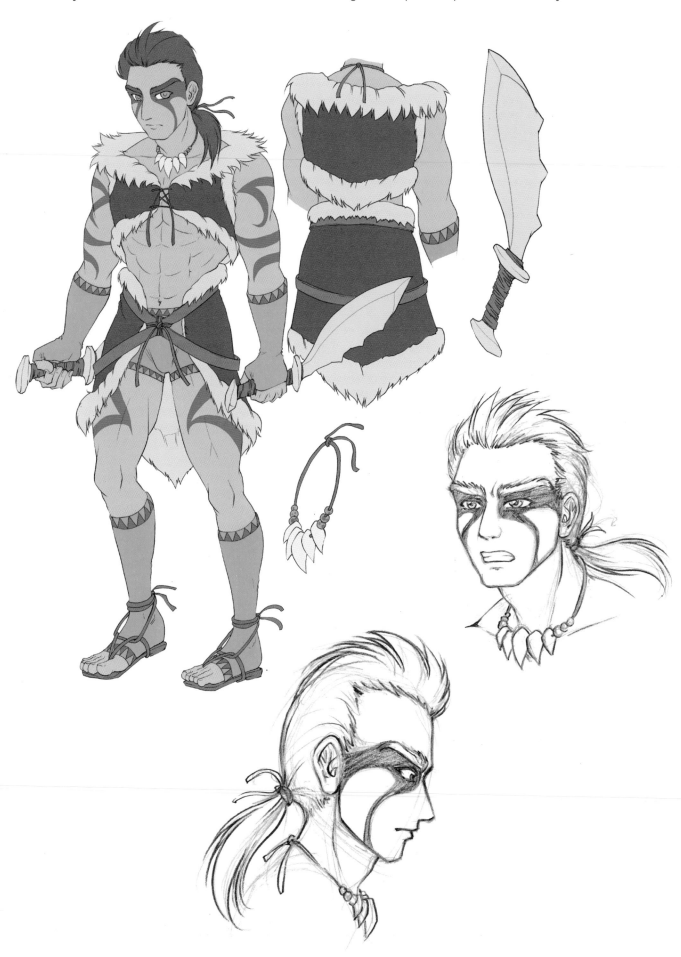

PRACTICE HERE!

Design Khaidu's tattoos and war paint, keeping in mind that markings on the body are often used to symbolize a warrior's status and experiences.

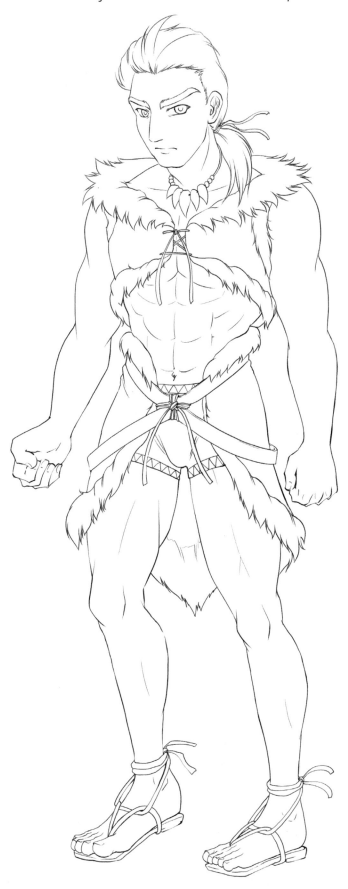

STEP-BY-STEP: WARRIOR

DRAW KHAIDU AS HE CONFRONTS A GIANT HORNED SERPENT ON A MOUNTAINTOP. FEATURE PLENTY OF ACTION IN YOUR IMAGE!

I sketched with colored pencils, inked with fineliner pens, and added color with markers.

Sketch Khaidu the warrior just as the serpent is poised to strike. Use the serpent's coils to fill the space. With a fairly thick fineliner pen, ink the warrior (he's in the foreground; thicker lines convey this position). Switch to a thinner pen for the serpent and the rocks.

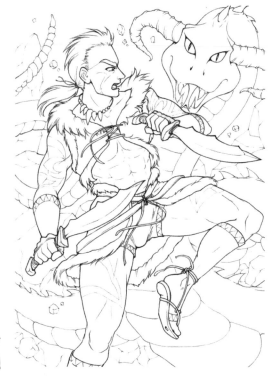

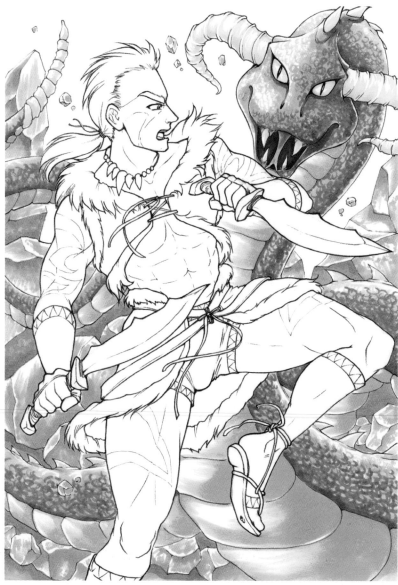

For strong, sun-bleached lighting, use light- and medium-toned markers to color in the background elements.

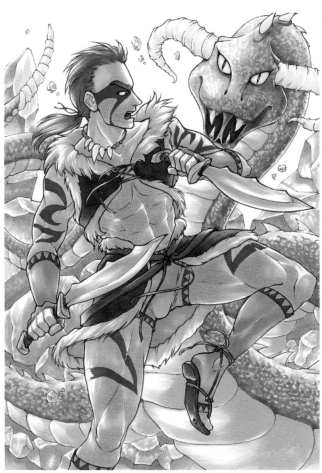

Having established the lighting, begin adding colors and shading to the warrior, leaving the outer edges white to create a backlit effect.

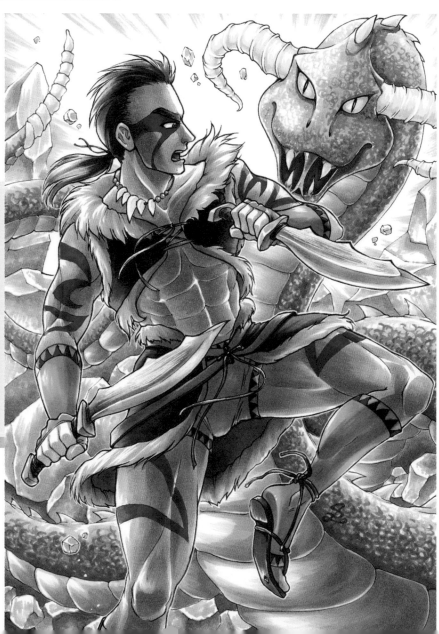

Background Tip
To increase the sense of depth in the background, add contrast using darker tones, working from light to dark and background to foreground. Blue marker strokes as radiating lines of emphasis in the sky add to the action.

ANGEL

IN A TYPICAL MANGA STORY, ANGELS ARE DRAWN AS BEAUTIFUL, PURE BEINGS SYMBOLIZING GOODNESS AND LIGHT. THEY OFTEN SERVE AS GUARDIANS OR PROTECTORS, FLYING IN TO RESCUE THOSE IN NEED, FIGHT OFF EVIL, AND DISPEL DARKNESS.

Halo: To imply a feeling of radiance, angels are sometimes shown with a shining halo on the head or even a glow around the whole body. Create interesting shapes for your angels.

Robes: In classical paintings, angels are often dressed in flowing, fluttering robes and sashes.

Wings: Imagine the snowy white wings of a dove and how they create a feeling of purity and peace. Look at birds' feathers for help with drawing an angel's wings.

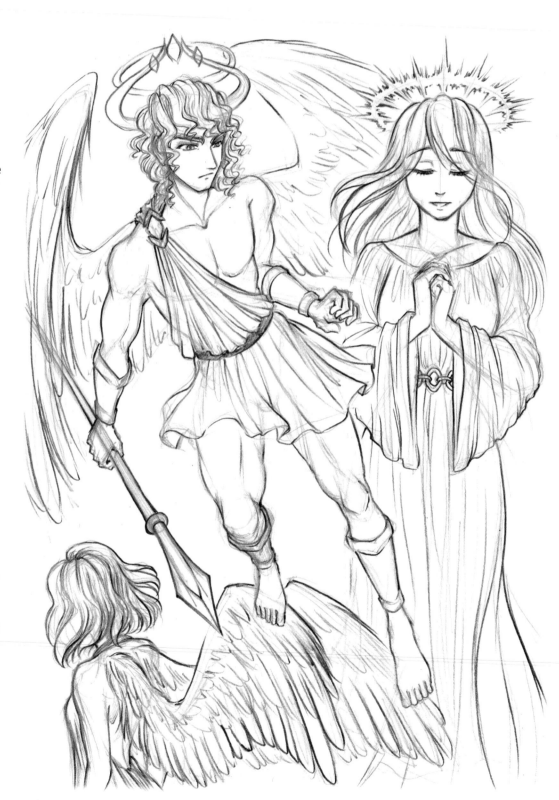

CHARACTER SHOWCASE: SERAPHIEL

Seraphiel is a high-ranking archangel with six wings as opposed to the usual two. Archangels are the most powerful angels, leading and assigning tasks to other angels around the world, as well as taking on the most difficult challenges in the fight against evil.

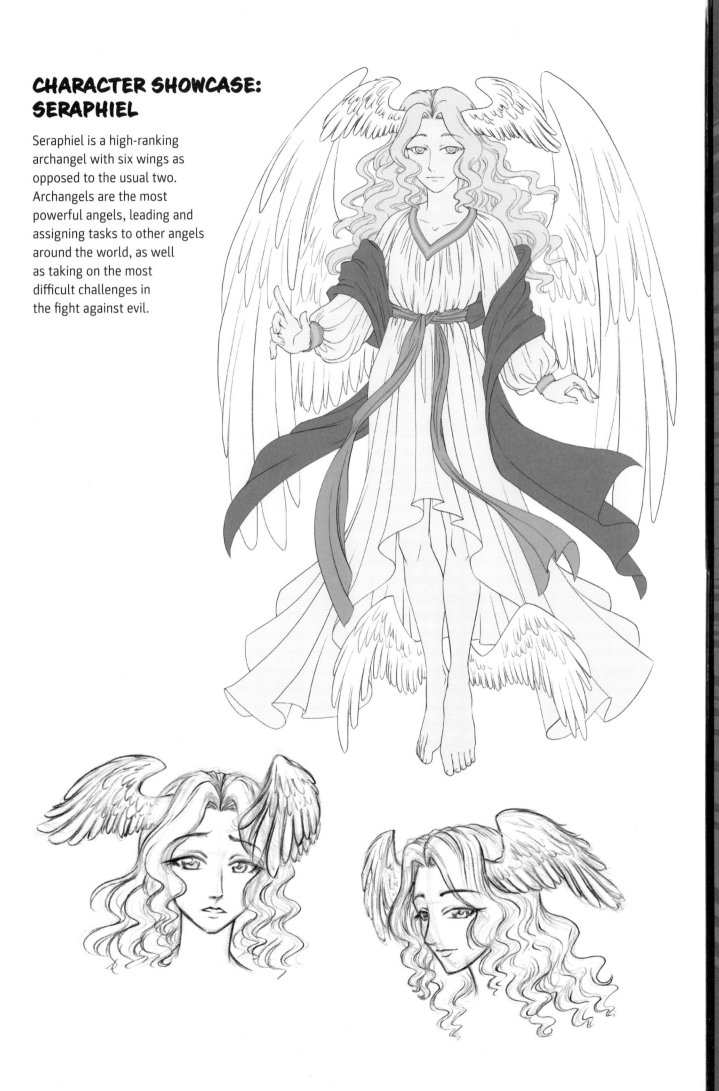

STEP-BY-STEP: ANGEL

TAKE INSPIRATION FROM CLASSICAL PAINTINGS AS YOU SKETCH AND COLOR THIS ANGEL.

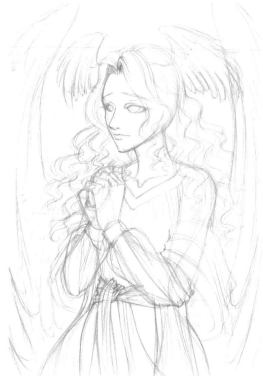

Sketch Seraphiel in a praying position: looking up toward the light, with wings folded slightly. Use a medium close-up depiction to accurately represent the facial expression.

I sketched my character in pencil; then I scanned the image and painted it digitally.

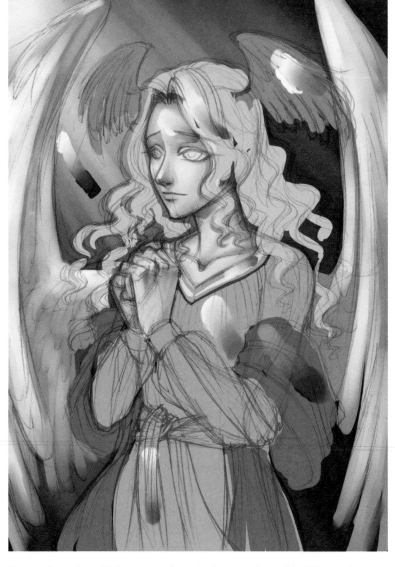

To create the look of a traditional oil painting, do all of your coloring on one layer. Keep the lines on one layer as guidelines; then on the color layer, fill in with dark brown and add your color palette from light to dark.

Pipette from the middle tones of your palette and roughly fill in some base colors directly onto the dark brown of the color layer. Use a mixture of highlight and shadow tones.

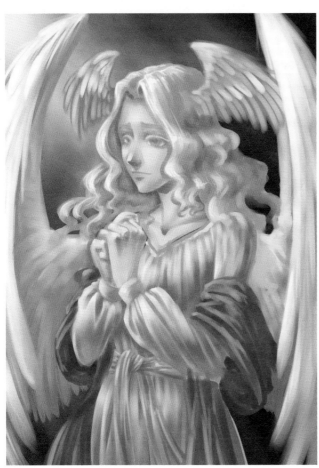

Continue to pipette from your palette and paint highlights and shadows across the whole piece. Toggle the line art layer on and off to check for sufficient definition in the paintwork. Then, working from the back, add fine details with distinct brushstrokes, and increase the contrast.

Background Tip
A traditional portrait painting highlights the subject more than the background. A dark color gradient with a streak of light from the corner is a simple but effective way to create a soft glow on your subject. Obvious brushstrokes can be seen around the edges.

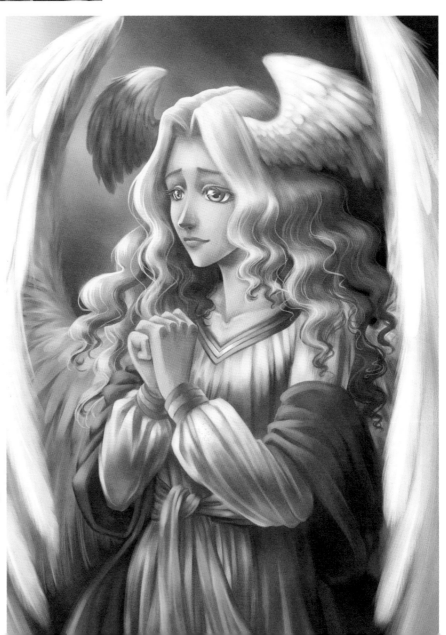

MECHA PILOT

IN JAPAN, GIANT ROBOTS ARE FEATURED IN VIDEO GAMES, AS FIGURINES, AND OF COURSE, ACROSS MANGA SERIES. THESE STALWARTS OF JAPANESE SCI-FI REQUIRE SKILLED PILOTS, WHO ARE FREQUENTLY THE MAIN CHARACTERS OF THE GENRE.

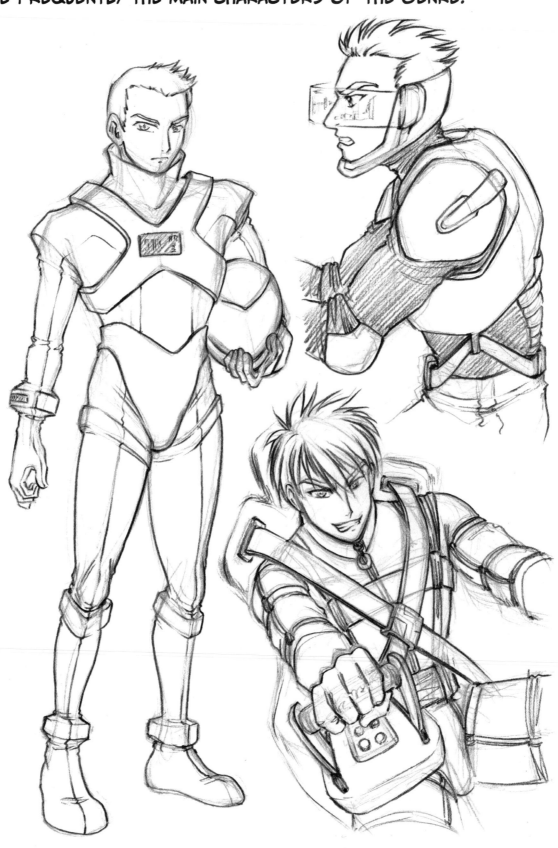

Fit: Think about the flight suits worn by modern-day pilots of supersonic jets, as well as athletes' skin suits. A mecha pilot's suit must allow for freedom of movement to access the controls and to make a quick escape, so their clothing can be loose or skin tight.

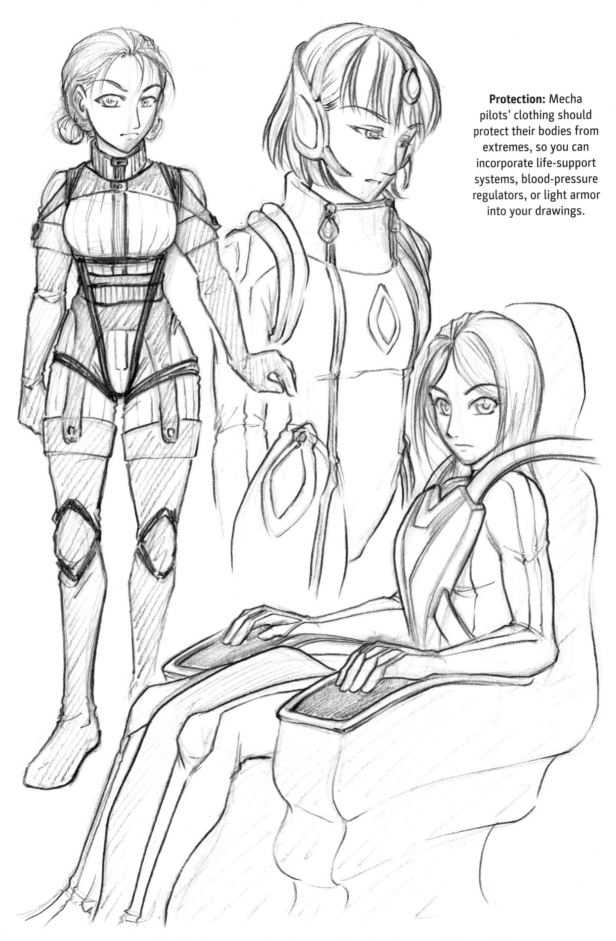

Protection: Mecha pilots' clothing should protect their bodies from extremes, so you can incorporate life-support systems, blood-pressure regulators, or light armor into your drawings.

Connections: Add technology to your drawing. How does the pilot control the mecha? Is there a brain or neural link in the suit or headset, or are there controls in the pilot's seat?

CHARACTER SHOWCASE: LUMINA

Lumina's planet is under siege from alien forces. Although young, she is one of the few who can naturally communicate with the soul stones used in the control system of her planet's defensive robots, so she was trained as a pilot from an early age.

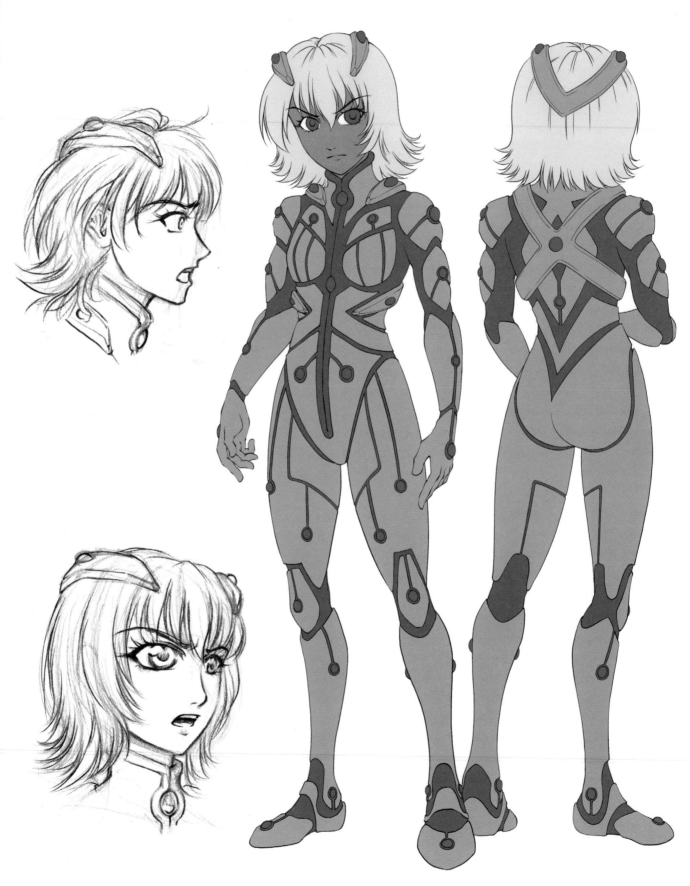

PRACTICE HERE!

Lumina's suit is designed to be worn in an enclosed cockpit. She controls her mecha through the glowing stones around key parts of her body. Can you design an alternative suit that does the same thing?

STEP-BY-STEP: MECHA PILOT

DRAW THE PILOT IN THE COCKPIT USING HER SEAT AND DIGITAL/ HOLOGRAPHIC CONTROL SYSTEM. ADD DEPTH AND DRAMA BY INCLUDING ANOTHER ROBOT IN THE DISTANCE.

I drew the figure with mechanical and colored pencils; then I scanned and colored it digitally.

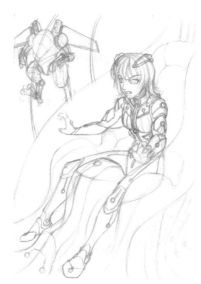

Sketch lightly with a bright colored pencil.

Fill in the midtone colors as your base color layer underneath the lines.

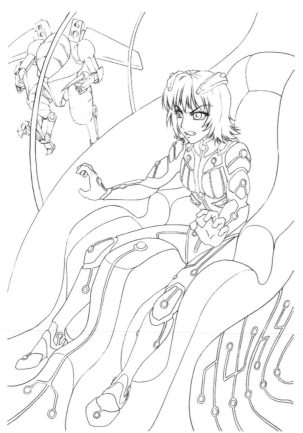

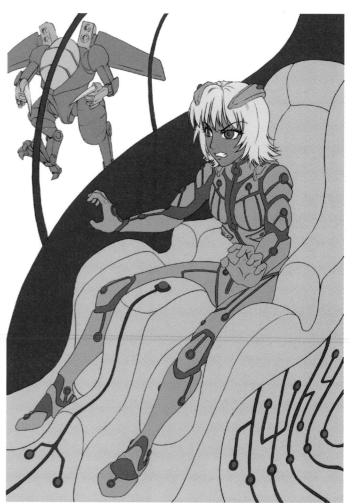

Using a black pencil with thin lead, go over your sketch with thin, precise lines. Then scan and filter out the colors by reducing the saturation levels and increasing the contrast.

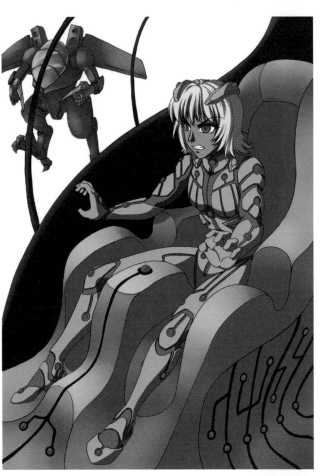

Add shadows on another layer and use the "shade"/"linear burn" setting so the colors are saturated to suit the strange lighting in the cockpit. Add glowing effects to the character's eyes and pink stones to show they're active; then create floating displays at her fingertips and in front of her eyes.

Background Tip
For an effective space background, don't just draw stars over a black background. Scatter in some space dust and clouds of distant galaxies in glowing colors.

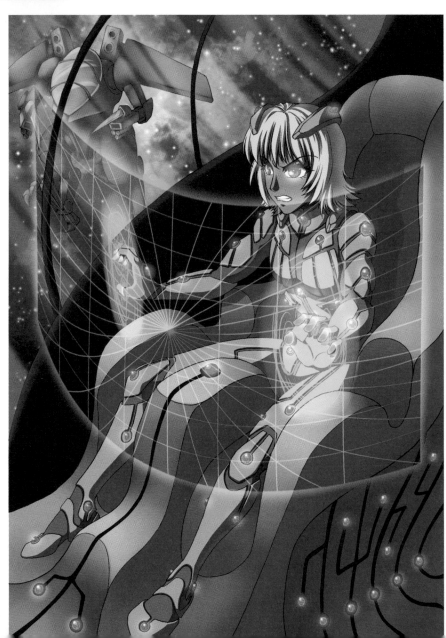

CYBORG WARRIOR

EVER SINCE ROBOTS WERE FIRST IMAGINED, CYBORGS HAVE PLAYED A ROLE AS WELL. HYBRIDS OF HUMANS AND ROBOTS, THEY CAN BE MOSTLY ORGANIC WITH ONLY SOME ROBOTIC LIMBS AND ENHANCEMENTS. OTHERS ARE ALMOST ENTIRELY ARTIFICIAL AND FEATURE JUST A HUMAN BRAIN INSIDE A METAL SHELL.

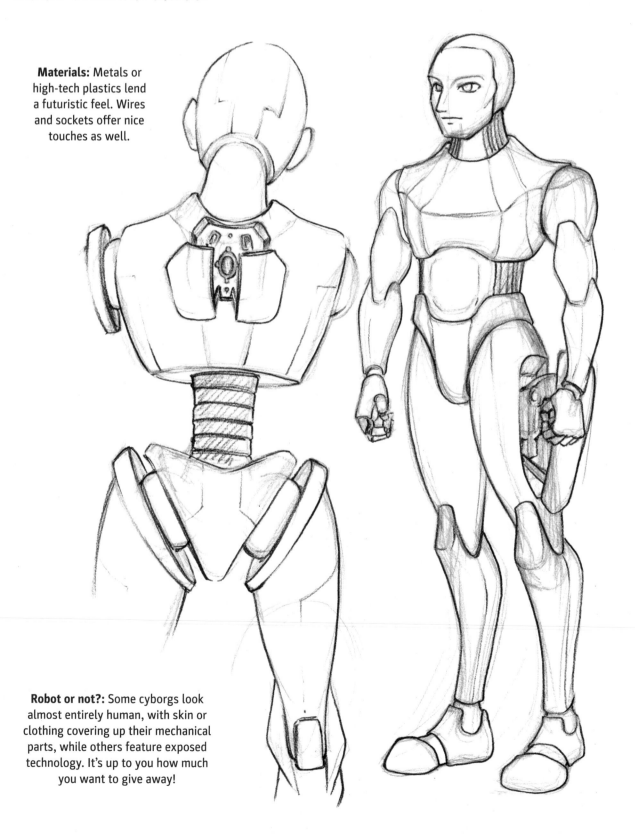

Materials: Metals or high-tech plastics lend a futuristic feel. Wires and sockets offer nice touches as well.

Robot or not?: Some cyborgs look almost entirely human, with skin or clothing covering up their mechanical parts, while others feature exposed technology. It's up to you how much you want to give away!

Joints: Similar to designing armor, you need to allow for movement in all the jointed areas, so incorporate ball joints, hinges, and rotating discs into any exposed sections.

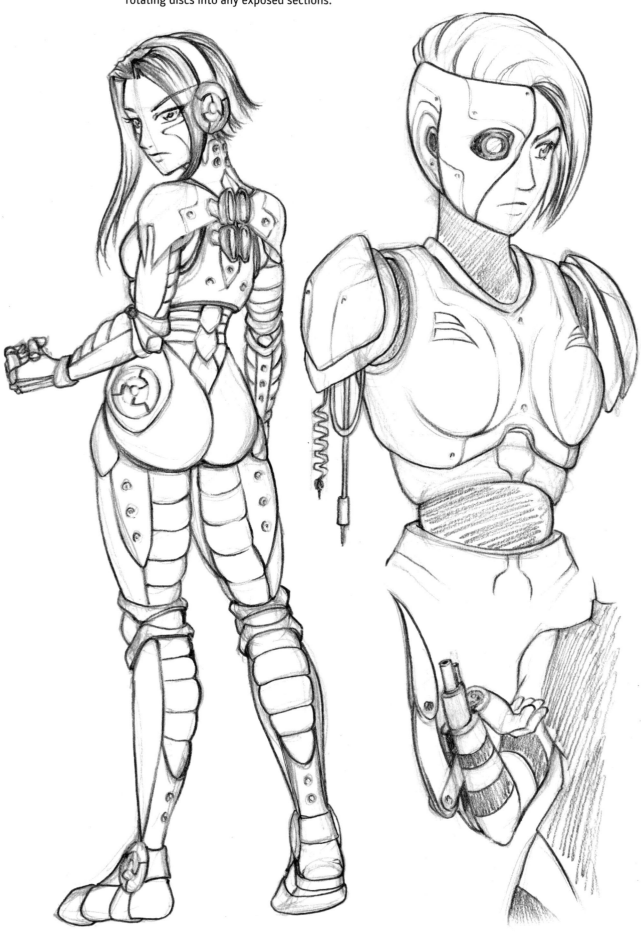

Concealed weapons: A robotic arm or leg might have space to hide a gun or blade. Design it so that a panel could lift away or fold out to reveal the weapon.

CHARACTER SHOWCASE: KIRA

Cyborg Kira was engineered as the
perfect soldier, with super strength and
targeting built into her eyes. However,
her facility was attacked while she was
being upgraded and she escaped—with
some metal limbs still exposed!

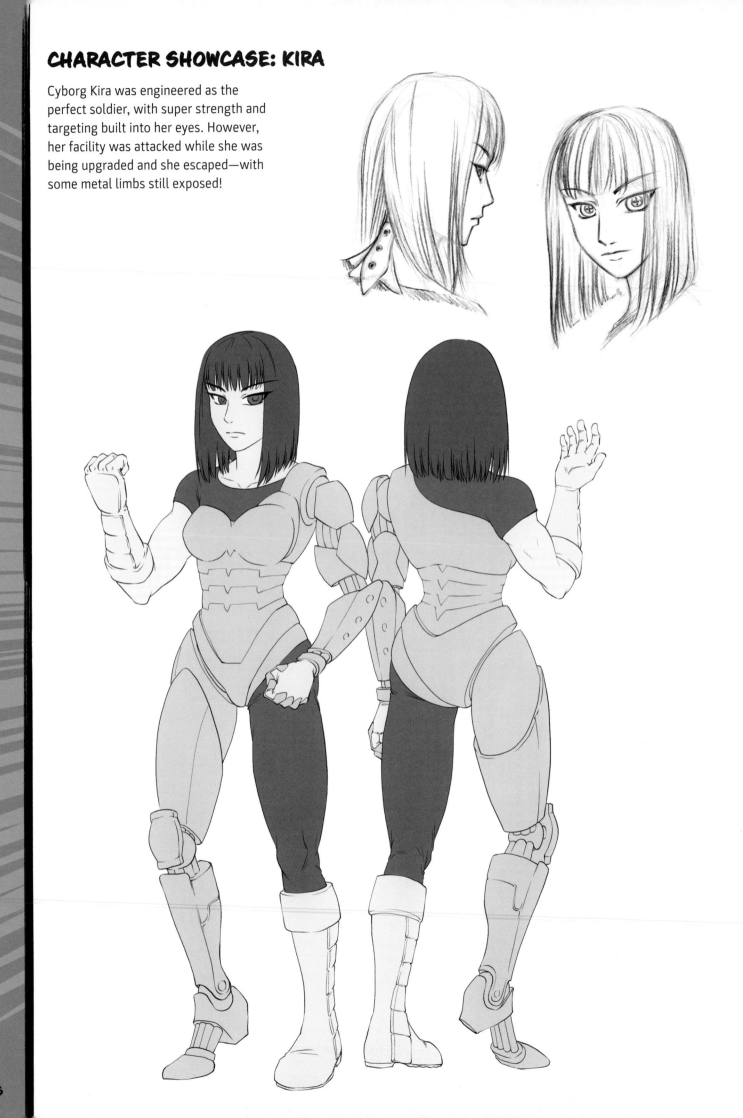

PRACTICE HERE!

Kira's current limb design is functional, but imagine if she had weapons built into her arms and legs. What would she carry, and how would you design her weapons?

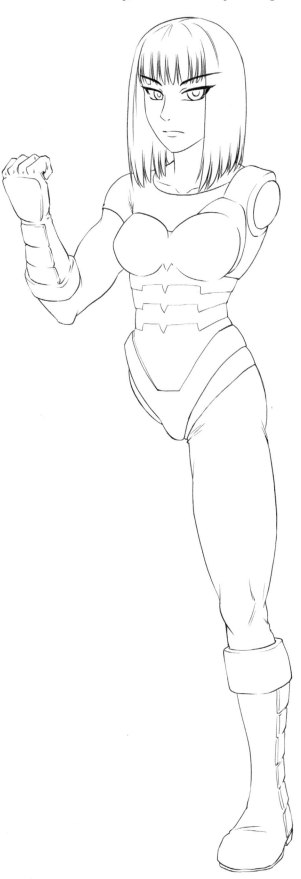

STEP-BY-STEP: CYBORG WARRIOR

IMAGINE A FEMALE CYBORG ON THE RUN, SNEAKING THROUGH A WASTELAND OF RUINED BUILDINGS. POSE HER CROUCHING BEHIND A WALL, AND INCLUDE DETAILS LIKE CRACKED PLASTER AND BULLET HOLES.

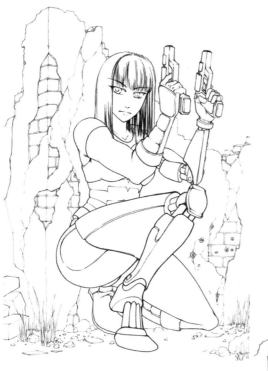

I sketched with pencil, inked with fineliner pens, and colored in with markers.

Sketch your figure in pencil. Carefully ink over the pencil lines with a thicker pen for the character and a thinner pen for the background.

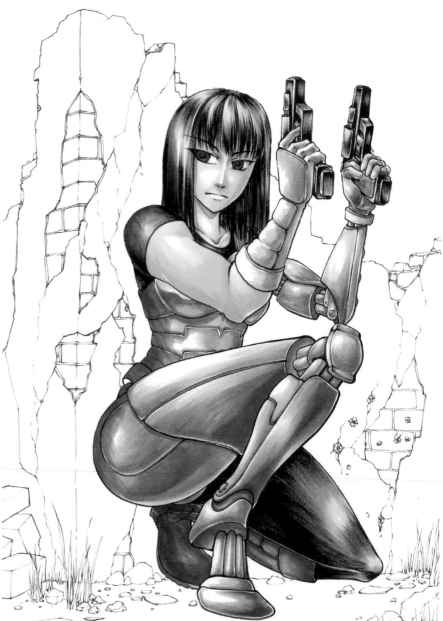

The final piece will feature less-defined lighting, so add colors to the main character with general lighting from above and to the right.

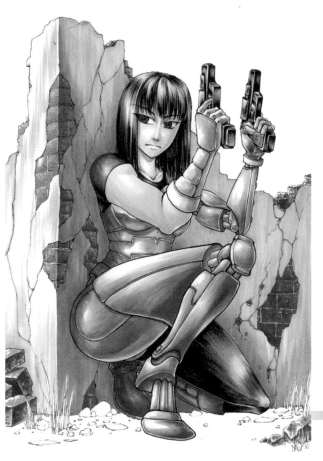

Add shading to the wall and bricks. It's a solid shape, so remember to keep one side of the wall lit and the other side more in shadow. Then add warm, dark grays to the sky and ground, matching levels of contrast with the character.

Background Tip
Streaks in your artwork aren't necessarily a bad thing. You can minimize them by working very wet, from dark to light. However, you can also consider the shapes and use them. For example, use circles for smoke or pebbles on the ground so that any streaks match the texture you hope to create.

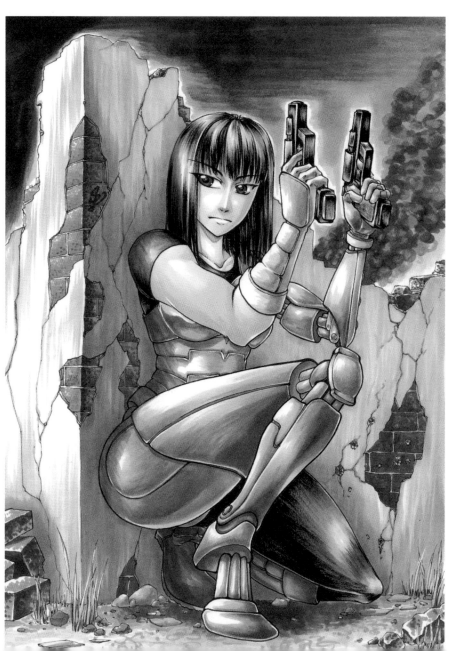

INTERSTELLAR IDOL

FROM SMOOTH CROONERS AND SPARKLING DIVAS TO EDGY PUNK ROCKERS, POP STARS MAKE CROWD-PLEASING POP-CULTURE ICONS. WHEN CHOOSING THE LEAD CHARACTER FOR YOUR SCI-FI STORY, WHO COULD BE MORE CHARISMATIC THAN A POP STAR WHO'S FAMOUS THROUGHOUT THE GALAXY?

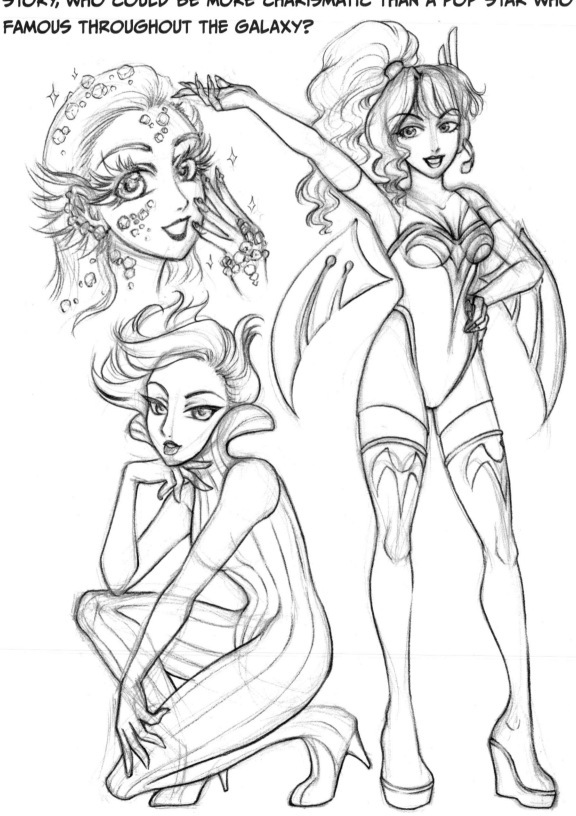

Shapes: Pop stars love to shock fans with attention-grabbing outfits that feature bold lines and silhouettes. Exaggerate their shapes with ridiculously high heels, form-fitting suits, and large collars.

Technology: Pop stars might enhance their acts by projecting holograms, using gravity-defying props, or incorporating their microphones and earpieces into elaborate hair pieces.

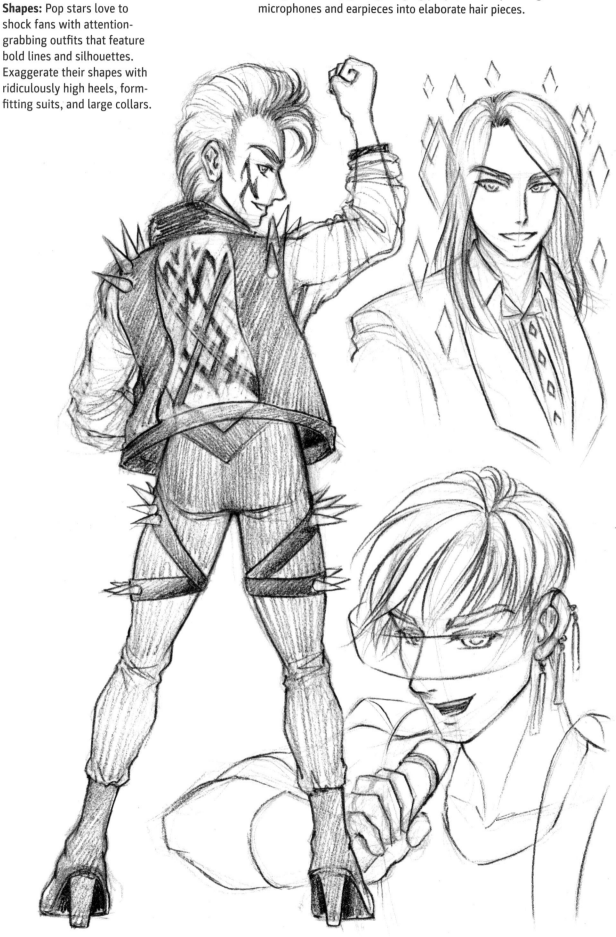

Materials: Draw high-tech, man-made fabrics with a futuristic feel. Think transparent panels, glowing threads, and concealed structures featuring boning or fastenings.

CHARACTER SHOWCASE: THE ANGEL OF MUSIC

Known throughout the Milky Way as "the Angel of Music," Israfel "Izzy" Edwards styles herself accordingly, using winged headphones and anti-gravity spheres to perform incredible aerial dance routines.

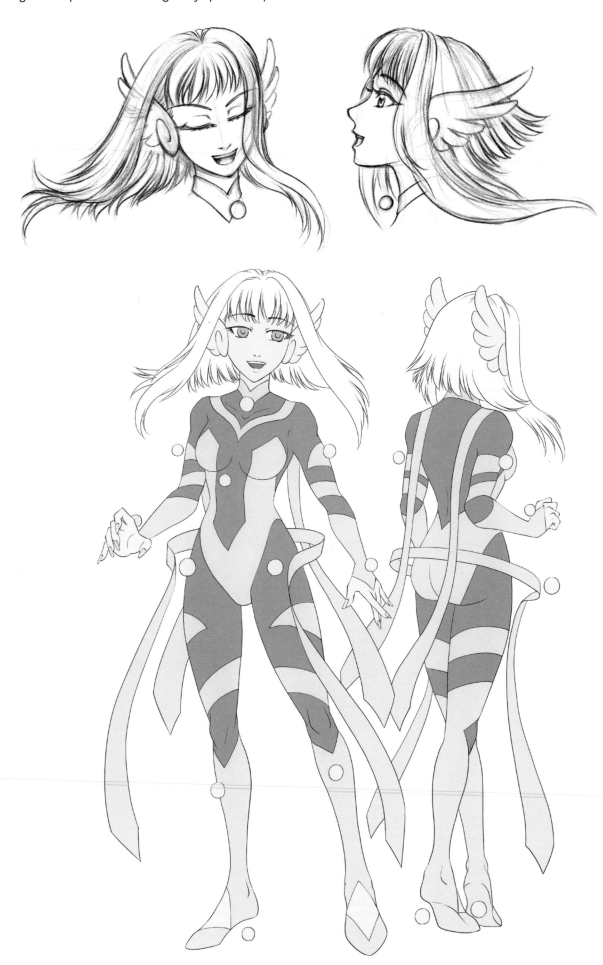

PRACTICE HERE!

No self-respecting pop star stays in one outfit for an entire concert! Keeping in mind Izzy's love of wings, design an alternative costume for her to wear during the second half of her show.

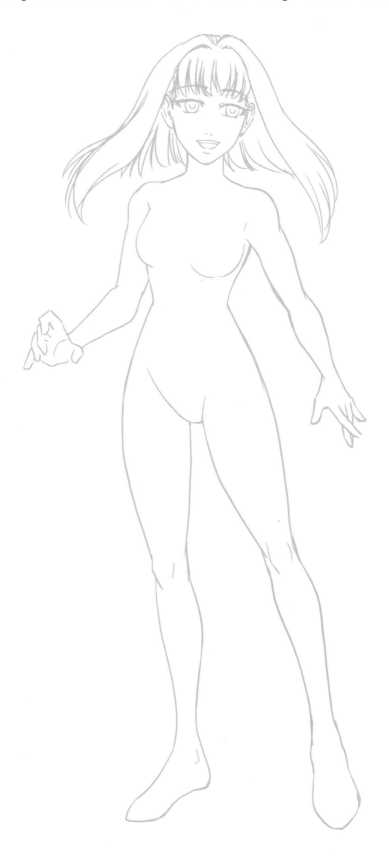

STEP-BY-STEP: INTERSTELLAR IDOL

COMPOSE THIS PICTURE TO SHOW OFF THE DETAILS OF YOUR CHARACTER'S FLOWING RIBBONS AND ANTI-GRAVITY SPHERES THAT KEEP HER AFLOAT.

I drew with mechanical pencils; then I scanned and colored in the image digitally.

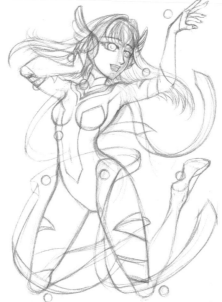

Sketch the figure using colored pencils.

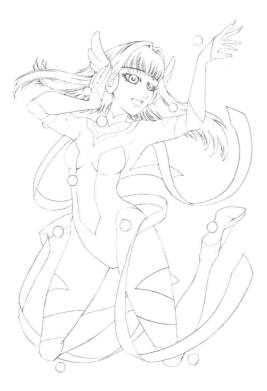

Draw over your line art with black lead; then scan and filter out the colors by reducing the saturation levels and increasing the contrast. Tint the lines with dark purple.

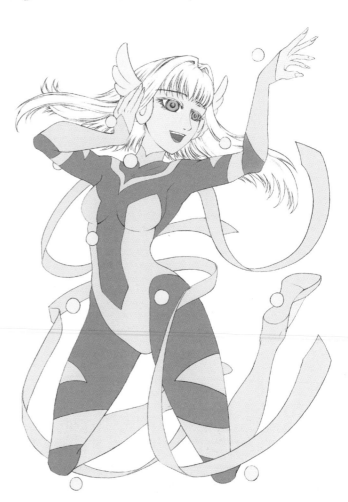

Flat fill the lines with pale base colors on a layer beneath the line art.

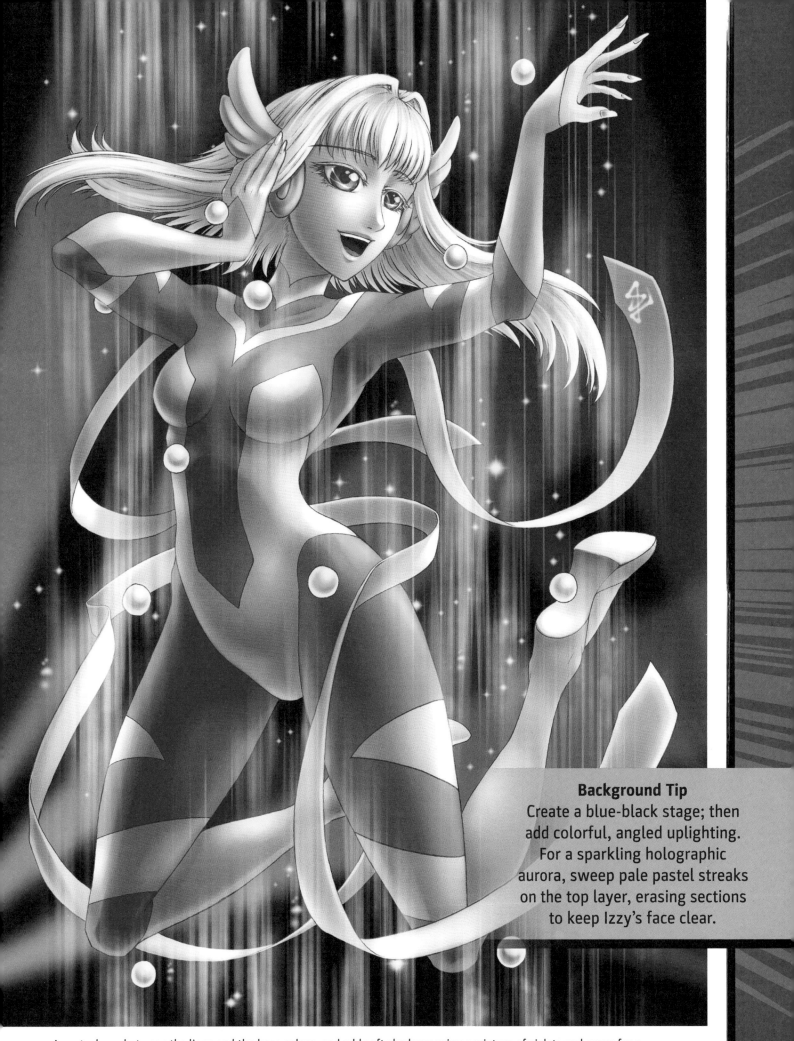

Background Tip
Create a blue-black stage; then add colorful, angled uplighting. For a sparkling holographic aurora, sweep pale pastel streaks on the top layer, erasing sections to keep Izzy's face clear.

Insert a layer between the lines and the base colors, and add soft shadows using a mixture of violets and cyans for a pearlescent effect. Light the character mostly from above, but remember that colorful stage lighting can come from many directions, so be generous with your highlights.

BOUNTY HUNTER

FOR A FUTURISTIC SCI-FI CHARACTER WHO'S GOOD AT USING A BLASTER AND TRACKING DOWN TARGETS, MAKING A LIVING AS A BOUNTY HUNTER ISN'T A BAD CHOICE!

Clothing: Bounty hunters are usually lone wolves and wear their own unique outfits—sometimes mismatched and cobbled together, and often a little damaged, from past adventures.

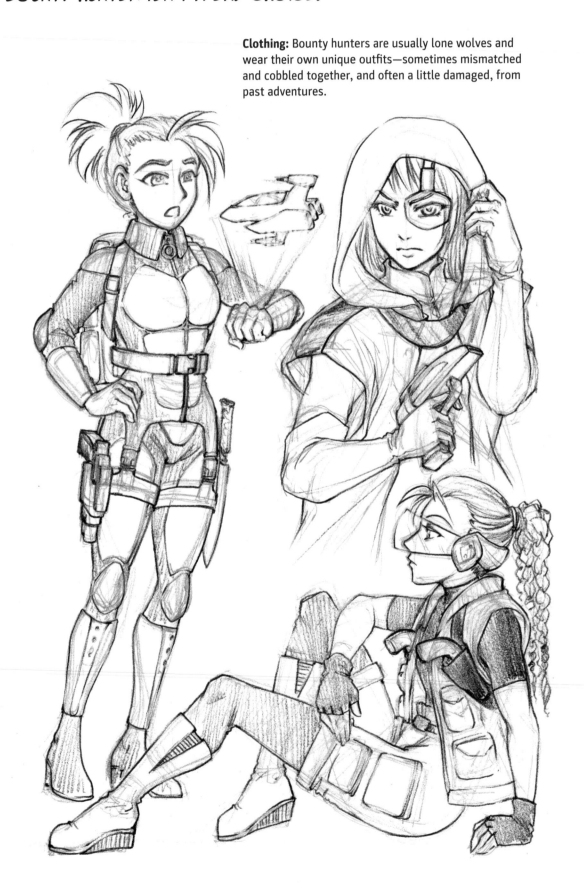

Well-armed: This is a dangerous career that may require venturing into unfamiliar places and fighting numerous enemies, so bounty hunters need lots of weapons and ammo on hand.

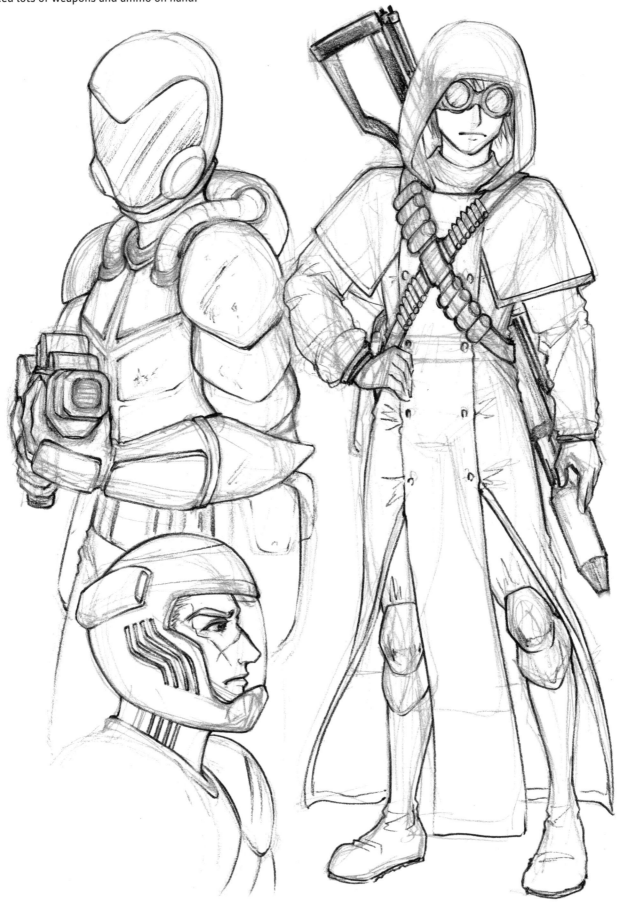

Practical elements: Add a hood or cape that's useful for sneaking around, lots of storage bags or pockets for picking up loot, light armor over the joints and torso, and devices to track down targets.

CHARACTER SHOWCASE: FARRON

Farron is like a cat on his ninth life: He somehow always survives the most impossible shoot-outs and manages to charm his way into the scariest gambling dens for leads on his targets. He loves getting paid, but he's a rogue with a heart who won't let a job compromise his morals.

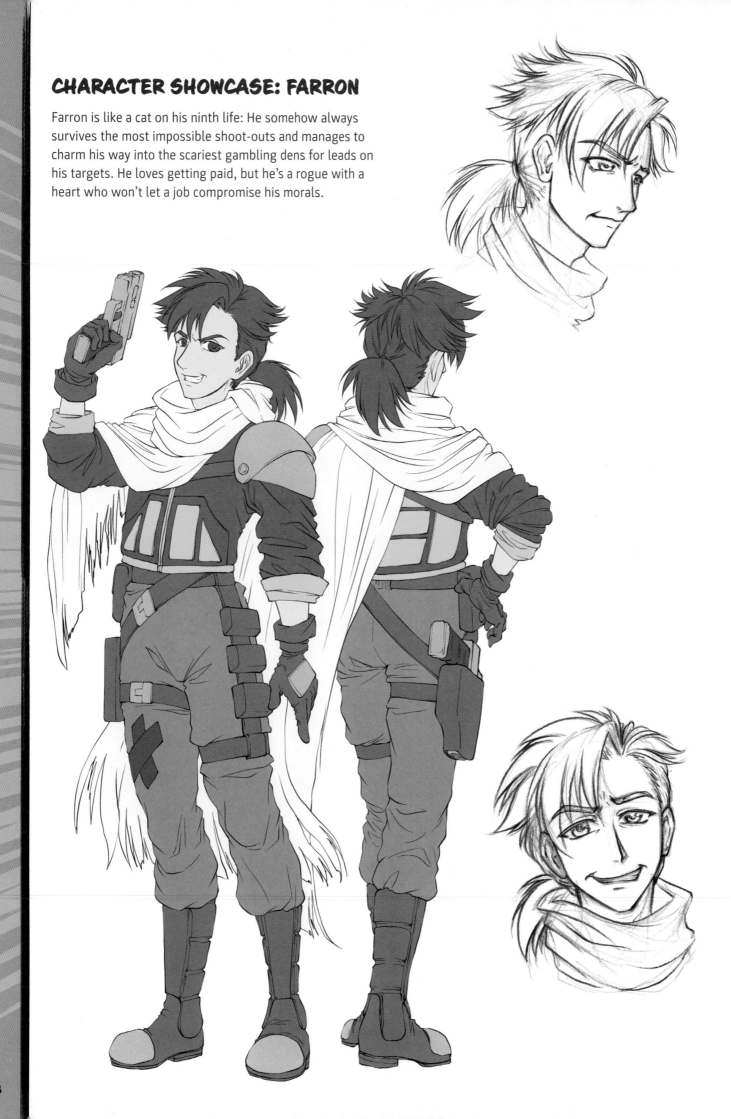

PRACTICE HERE!

Draw bounty hunters in action. These characters will do whatever it takes to find their quarry, whether it's sneaking around a corner, ambushing a gang, or crawling through tunnels. Try fleshing out the stick figures shown here with your own designs.

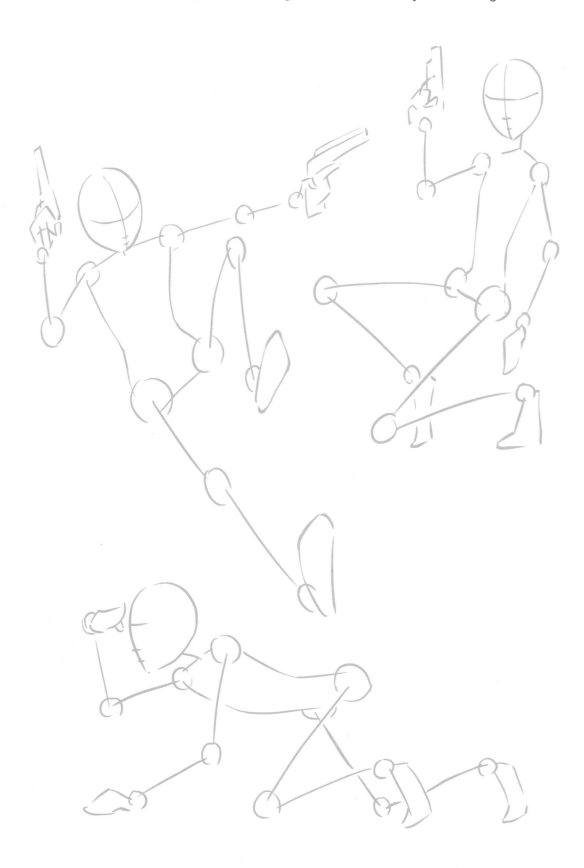

STEP-BY-STEP: BOUNTY HUNTER

FARRON THE BOUNTY HUNTER JUST FOUND A LEAD! DRAW HIM JUMPING INTO HIS SPACESHIP VIA THE LOADING RAMP.

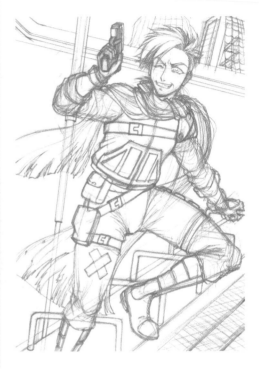

Sketch the figure in a medium close-up view framed by parts of the spaceship.

I drew this image with mechanical pencils, inked it with fineliner pens, and colored it in with markers.

Working quickly to blend, shade in the skin, keeping the paper wet and swapping out pens to achieve smooth gradients and soft highlights. Then focus on the darker parts of the outfit.

Ink over the pencil lines with marker-proof fineliner pens using thicker widths for the character and thinner nibs for the spaceship. Once fully dry, carefully erase the pencil lines.

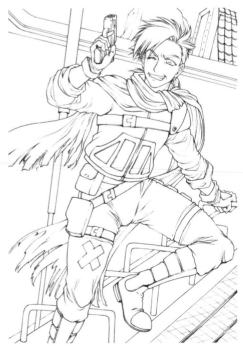

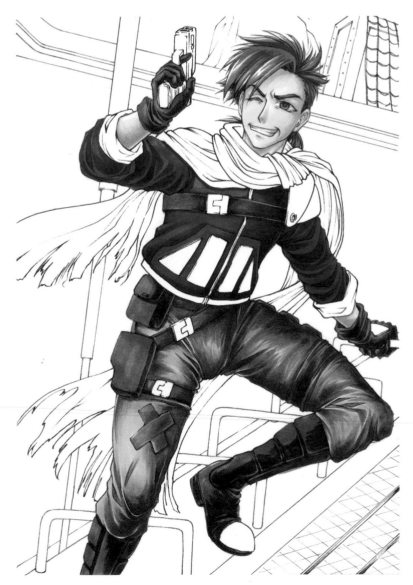

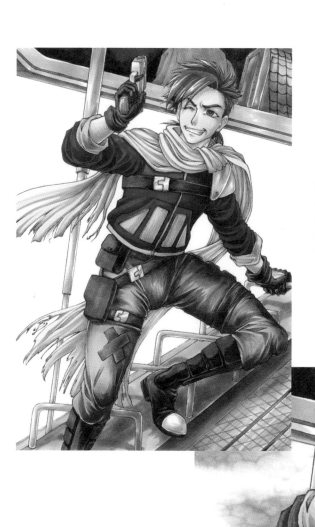

Now add the lighter areas of the image and parts of the spaceship. Go over your lines again with a black fineliner pen to keep the contrast and definition clear; then add bright highlights with a white gel pen and white colored pencil.

Background Tip
To create puffy, defined clouds, lay down parts of the sky in light blue-gray, leaving the paper white for cloudy areas. Use a clear marker to soak the paper with circles and ovals around the clouds' edges.

MECHANIC

SPACESHIPS AND ROBOTS NEED SOMEONE WHO CAN FIX THEM. ENTER THE MECHANIC! ALWAYS WILLING TO GET THEIR HANDS DIRTY, MECHANICS CARRY ALL KINDS OF COMPLEX TOOLS TO CREATE AND REPAIR A WIDE VARIETY OF MACHINES.

Protection: Mechanics typically wear aprons or overalls and may find elbow and knee pads useful for crawling under vehicles. Goggles and face masks are essential when using dangerous equipment.

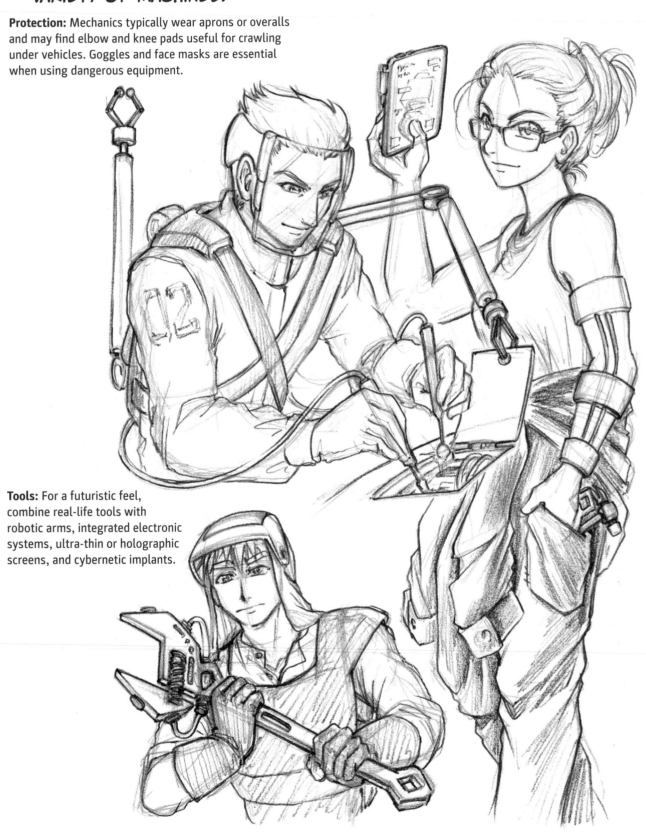

Tools: For a futuristic feel, combine real-life tools with robotic arms, integrated electronic systems, ultra-thin or holographic screens, and cybernetic implants.

CHARACTER SHOWCASE: MIRABELLE

Mirabelle is petite, but her projects are big! Her desert planet is on an important trade route, so she gets plenty of work, particularly from bounty hunters like Farron (page 108).

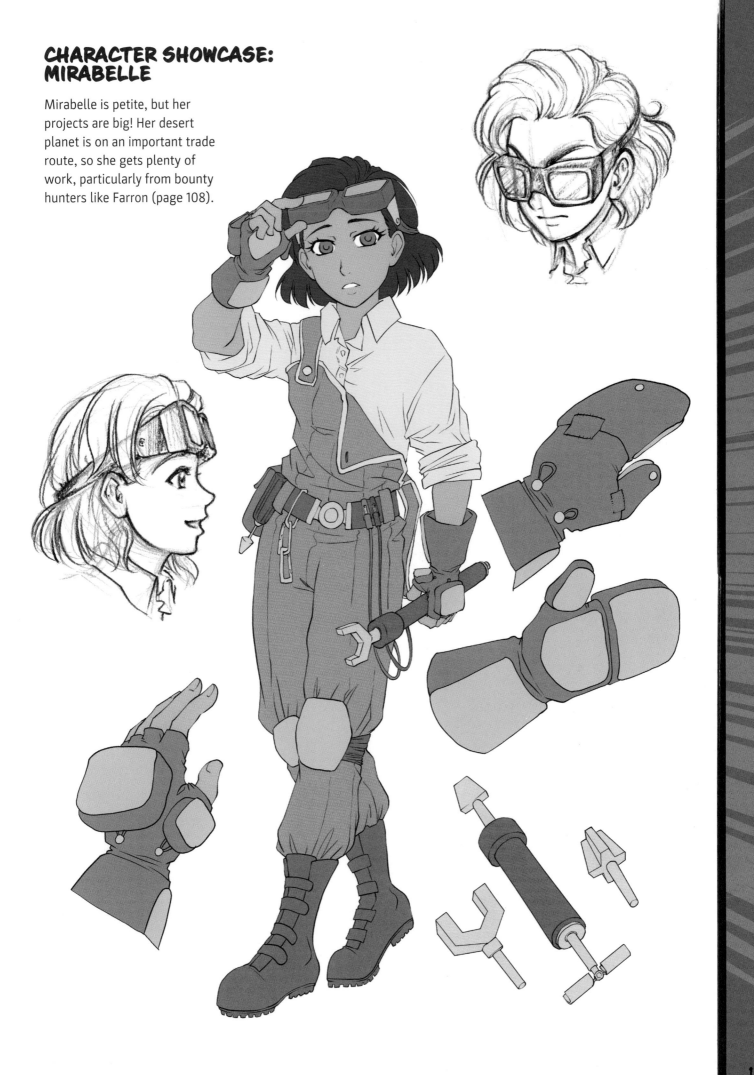

SPACE MARINE

THESE SPACE SOLDIERS ARE THE TOUGHEST OF ALL. HIGHLY TRAINED TO USE MULTIPLE WEAPONS AND CAPABLE OF EXECUTING MANY MILITARY STRATEGIES BOTH ON- AND OFF-PLANET, SPACE MARINES ARE PREPARED FOR ANYTHING THE ENEMY MIGHT THROW THEIR WAY.

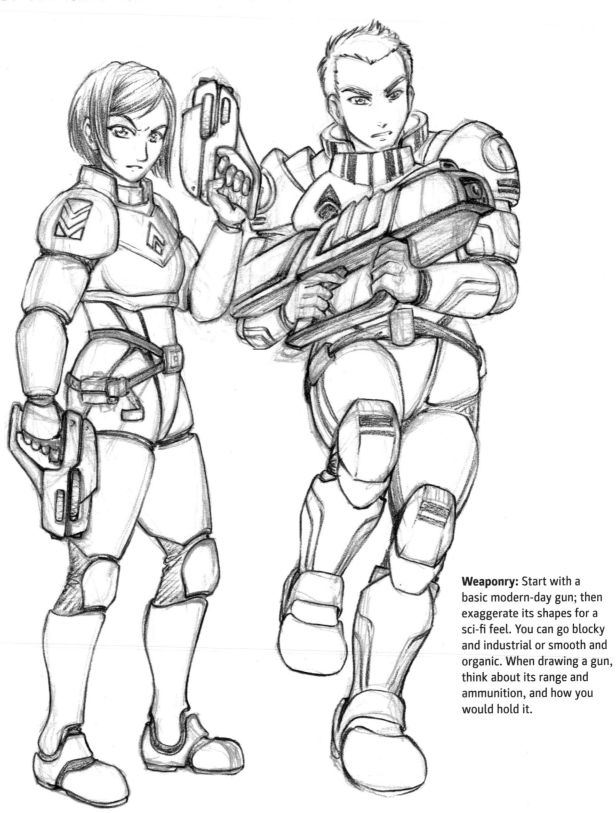

Weaponry: Start with a basic modern-day gun; then exaggerate its shapes for a sci-fi feel. You can go blocky and industrial or smooth and organic. When drawing a gun, think about its range and ammunition, and how you would hold it.

Armor: Space marines need to be well-armored but mobile. Their roles and weapon types can determine how heavy you should go: Pistol users must be light on their feet, while grenade launchers require major protection. If working in space, they need suits with life support and strong helmets.

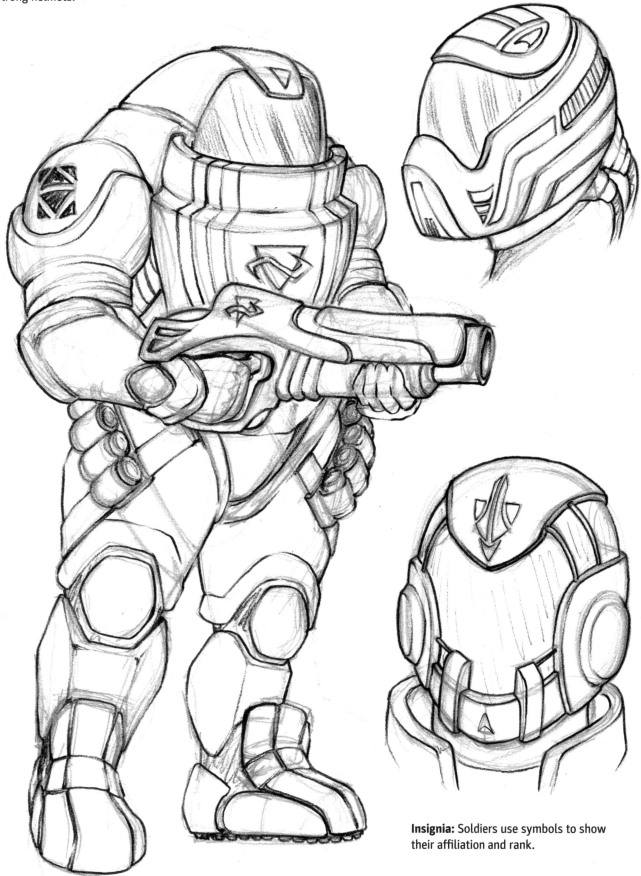

Insignia: Soldiers use symbols to show their affiliation and rank.

CHARACTER SHOWCASE: HEKTOR

A veteran of several planetary battles, Hektor has completed all kinds of missions in the most challenging of environments. He loves to get up-close and personal with his enemies, making his weapon of choice a compact shotgun.

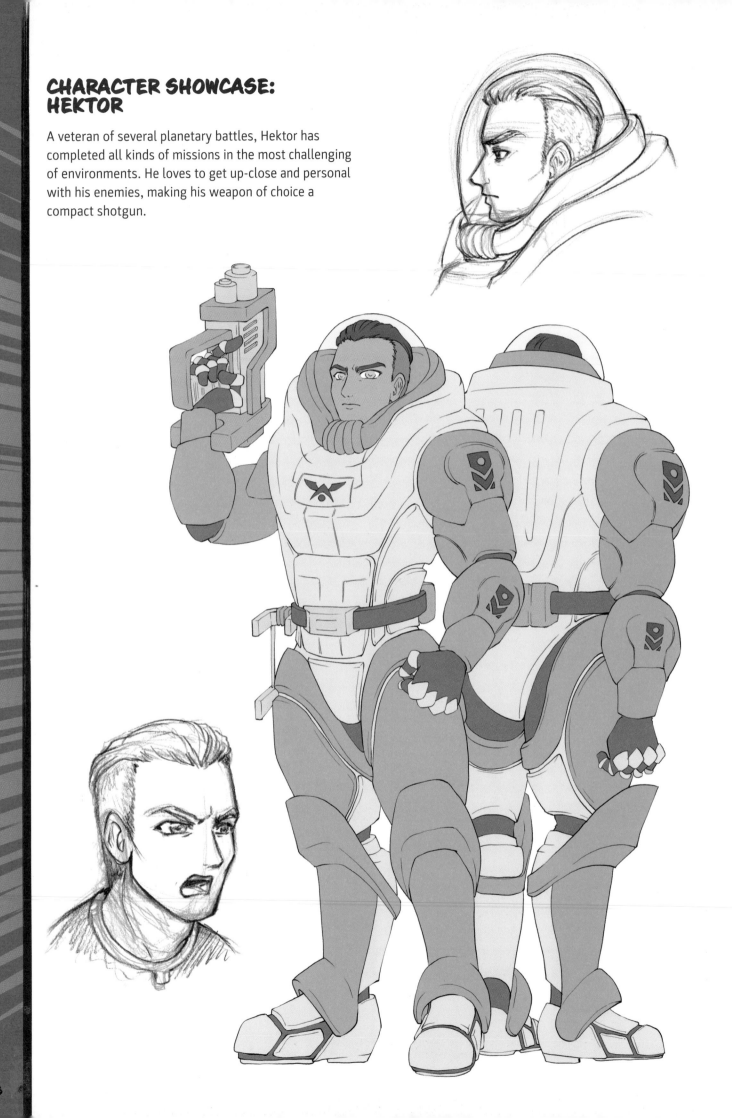

PRACTICE HERE!

By now, you're probably pretty good at fleshing out a body over a stick figure and at designing clothing over a body, but can you do it the other way around? Draw Hektor's body underneath his bulky, armored suit!

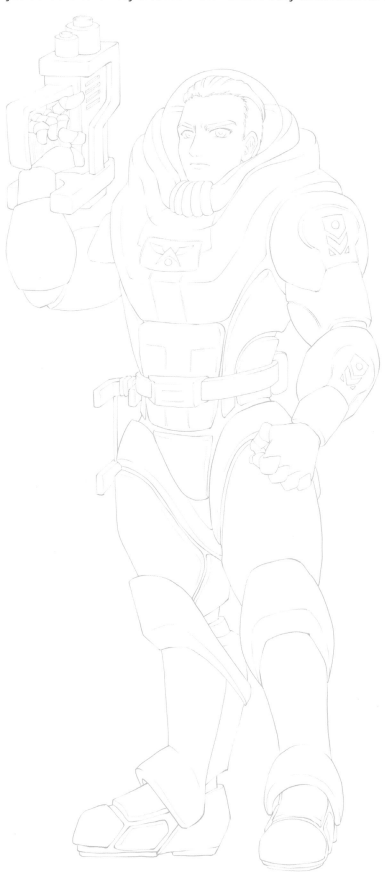

ESP/TELEKINESIS USER

SOMEONE WITH ESP, OR EXTRASENSORY PERCEPTION, CAN HAVE PARANORMAL CAPABILITIES AND MIGHT BE ABLE TO COMMUNICATE TELEPATHICALLY, MOVE OBJECTS WITH THE MIND, OR HAVE VISIONS OF THE FUTURE.

Auras: Their powers may also bring them an aura or a glow.

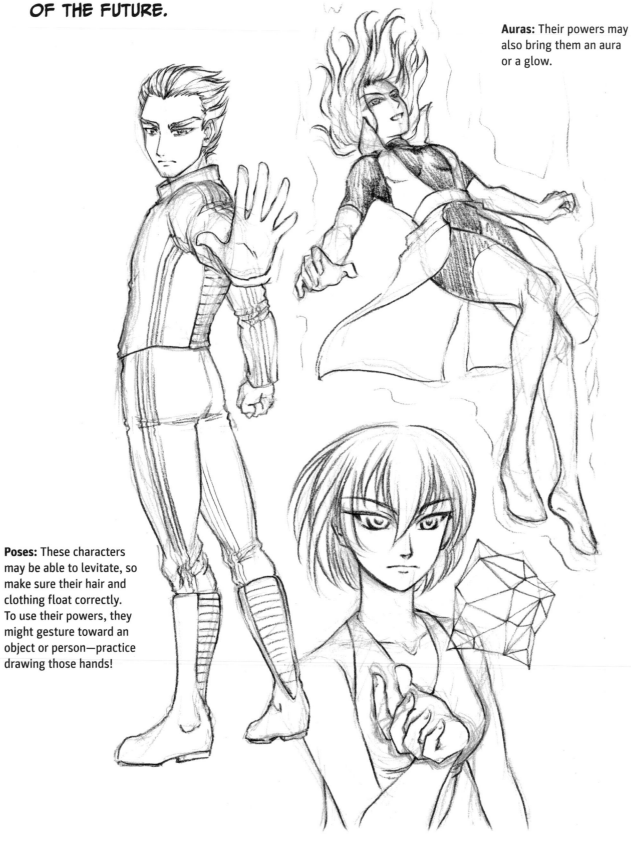

Poses: These characters may be able to levitate, so make sure their hair and clothing float correctly. To use their powers, they might gesture toward an object or person—practice drawing those hands!

CHARACTER SHOWCASE: DIO

Dio recently escaped from a laboratory, where she was experimented on to enhance her telekinetic powers. She is timid and frail, but when pushed too far, she lashes out with deadly psychic force.

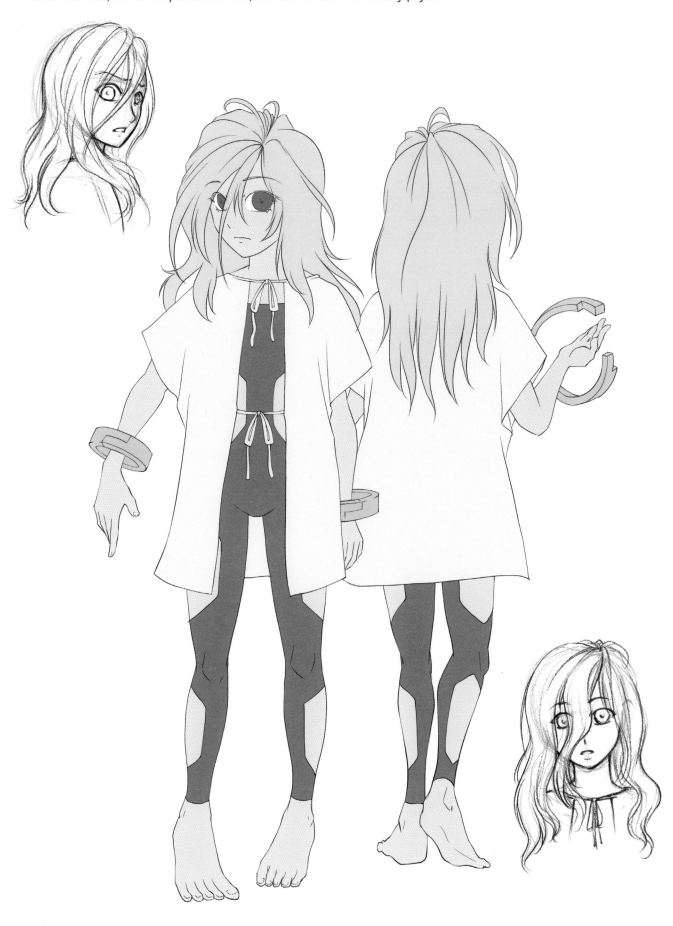

STEP-BY-STEP: ESP/ TELEKINESIS USER

TO DEMONSTRATE THIS CHARACTER'S ABILITIES, SKETCH HER FLOATING IN MID-AIR. IN THE BACKGROUND, DRAW A HAUNTING CLOSE-UP OF HER EYES.

I sketched and outlined this image with mechanical pencils; then I scanned and painted it digitally.

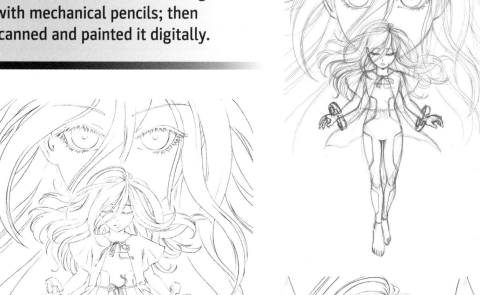

Sketch the figure with a light pink pencil that you can easily remove digitally.

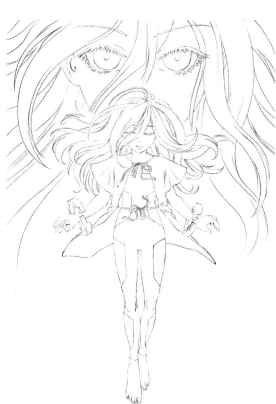

With thin mechanical pencil lead, neatly outline the sketch. Then scan and desaturate the image to remove the pink lines, leaving only the black outlines.

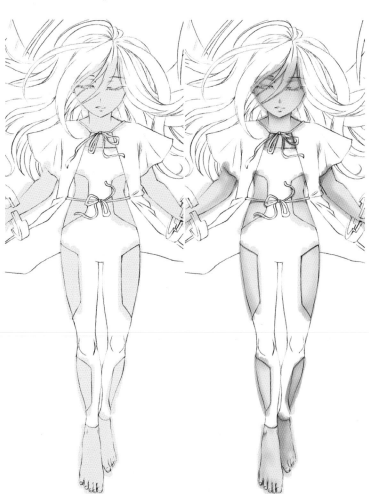

For a soft, airbrushed look, control your shading by using one layer per color; then lock or preserve the transparency so that you don't add more than necessary, starting with the skin.

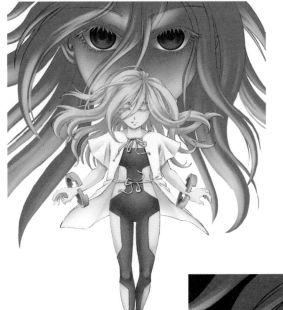

Continue adding and locking layers on top for your character's hair, bodysuit, and hospital gown. Then shade the background close-up of her face using uplighting for an eerie glow.

Background Tip
Digital work is great for adding special effects onto different layers. Fade out the close-up to a dark background; then add swirling patterns around the figure in white and bright colors. Place the background curve on a layer between the close-up and the full-body shot and the front curve on the top layer.

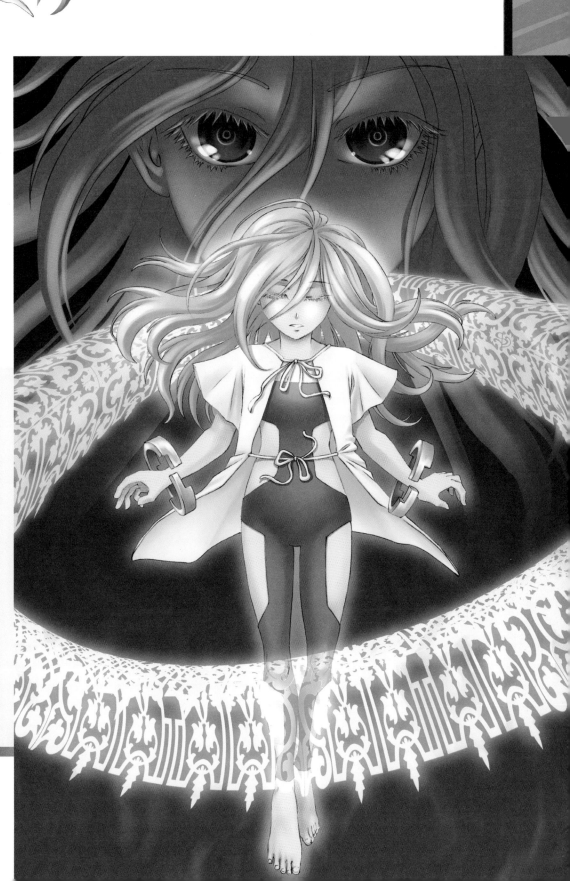

GALACTIC DIPLOMAT

POLITICS ARE A POPULAR STORYLINE IN ANY FUTURISTIC STORY. IN A SCI-FI WORLD, ALL KINDS OF HUMANS AND ALIENS CAN MEET TO REPRESENT THEIR VARIOUS HOME WORLDS.

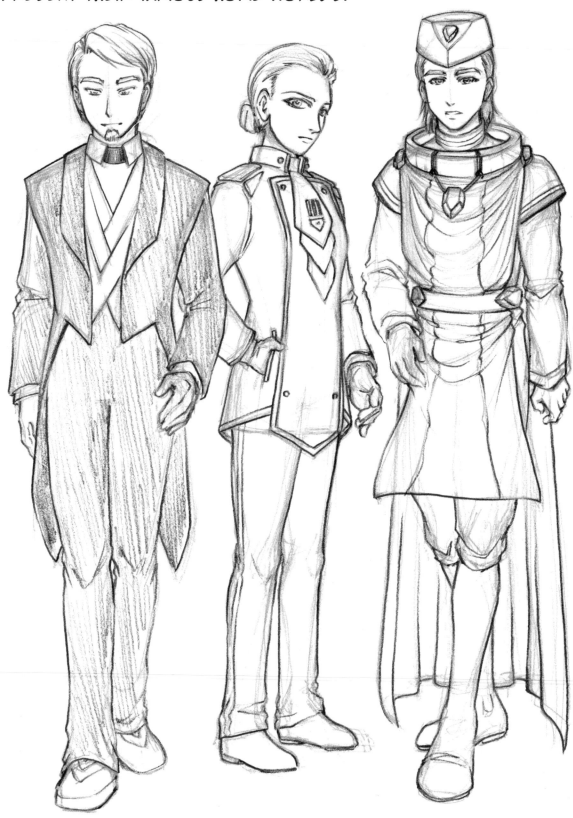

Job description: Diplomacy is conducted between representatives, so consider their titles. Your characters could be elected politicians like presidents or born into leadership like royalty, or they may have worked their way to the top of the military.

Alien races: If you're drawing a galaxy-wide event, make sure to showcase aliens with interesting body structures and outfits.

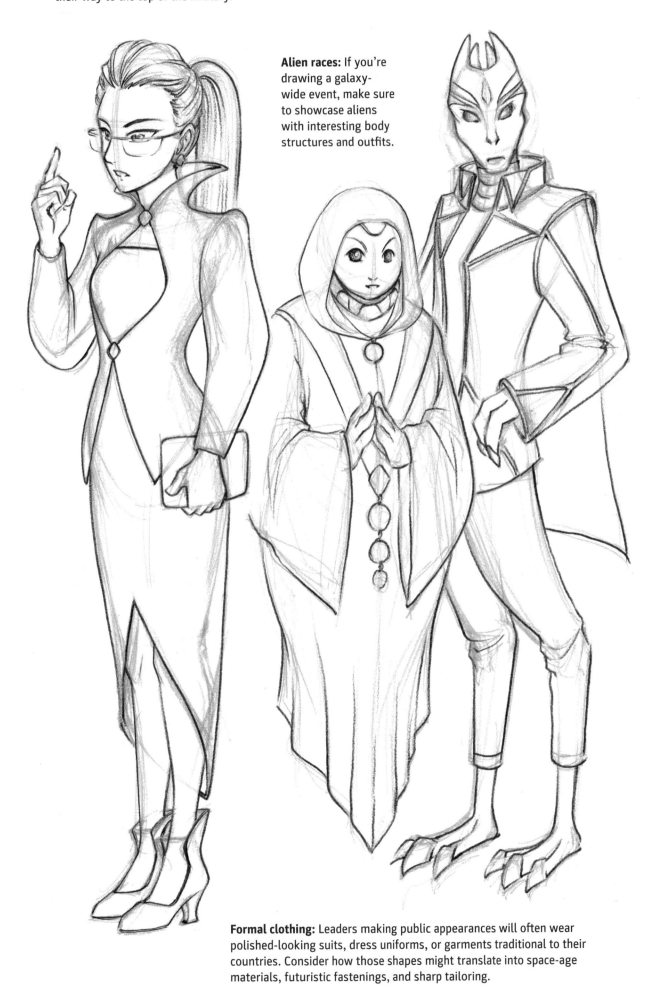

Formal clothing: Leaders making public appearances will often wear polished-looking suits, dress uniforms, or garments traditional to their countries. Consider how those shapes might translate into space-age materials, futuristic fastenings, and sharp tailoring.

CHARACTER SHOWCASE: EMPRESS ORALIS

Newly crowned Empress Oralis is young, but she's been preparing for this role from birth. One of her first duties as ruler of her planet is making her introductory galactic broadcast—so she's dressed to impress!

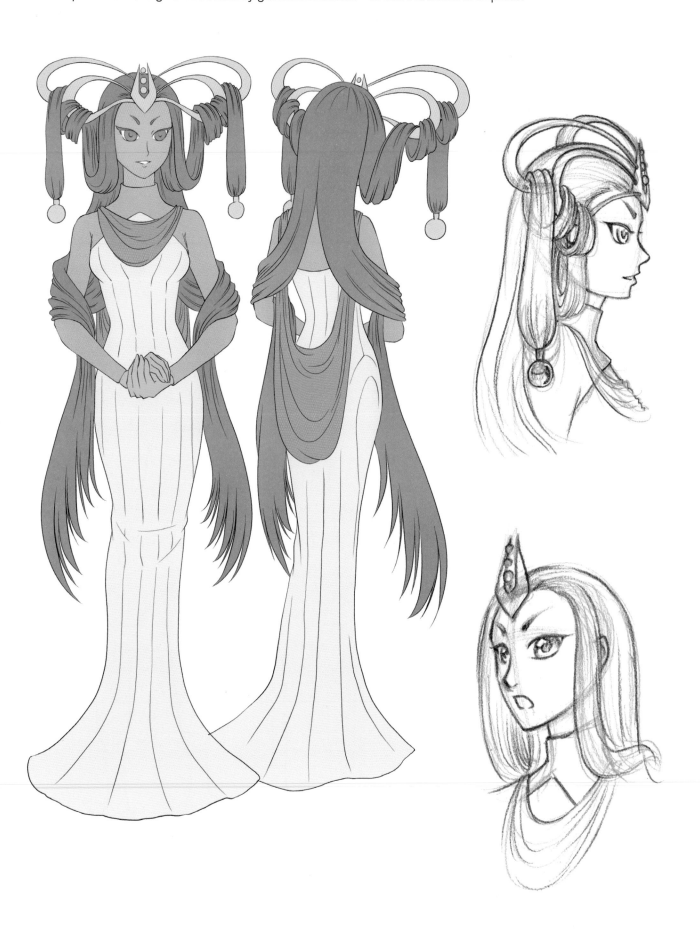

PRACTICE HERE!

Aliens can be any shape you want them to be, so I haven't included any guidelines here!
Sketch your own alien VIP below.

STEP-BY-STEP: GALACTIC DIPLOMAT

DRAW EMPRESS ORALIS AS SHE BROADCASTS LIVE TO THE REST OF THE GALAXY FROM HER HOLOGRAPHIC STUDIO! SHE STANDS IN FRONT OF A LECTERN, WHERE SHE CAN KEEP HER NOTES HIDDEN.

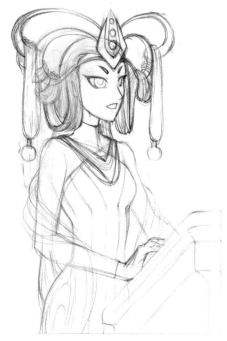

I sketched and then colored in the figure using colored pencils.

Sketch your character, exaggerating her proportions to hint at her alien origins.

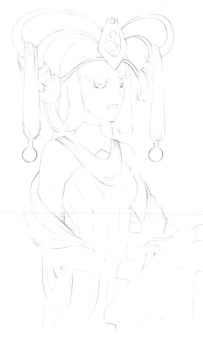

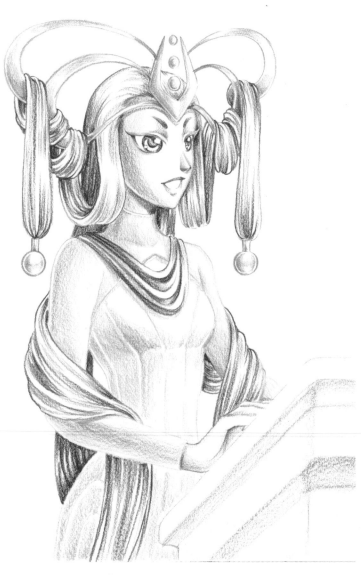

On a separate sheet of paper, trace over the sketch with a light box, using colored pencils for the outlines.

Begin shading using the darkest colored pencils, leaving lots of white on the paper. Sharpen your pencils often to keep the lines neat and bold.

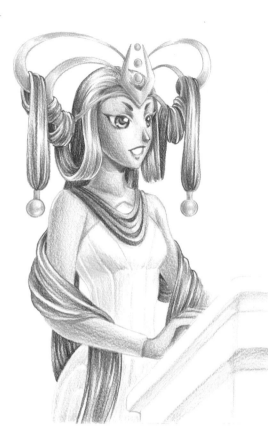

Layer lighter tones on top of the shadows. Use a mixture of warm and cool colors for a rich result.

Background Tip
To maintain the sense of brightness in the picture, keep the background abstract and draw various rectangles in bright colors circling around the figure to suggest her broadcast to millions of screens around the galaxy.

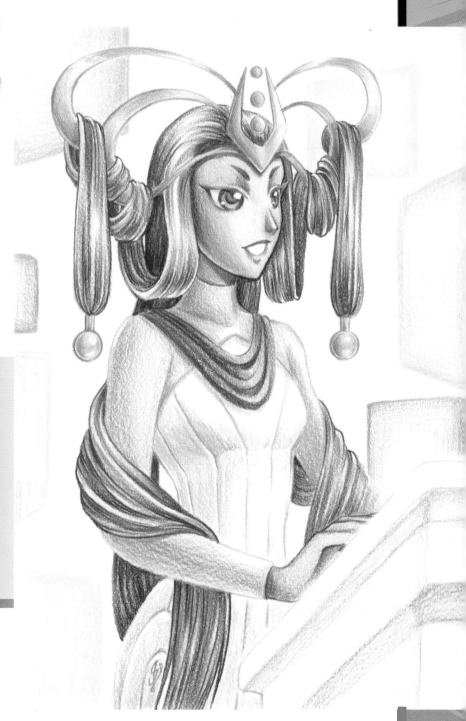

ABOUT THE ARTIST

Sonia Leong is an illustrator and a professional comic artist specializing in anime and manga. Her awards include Young Adult Library Services Association Quick Picks for Reluctant Young Adult Readers and Best Books for Young Adults 2008, TOKYOPOP Rising Stars of Manga, and the *NEO Magazine* manga competition.

Manga Shakespeare: Romeo and Juliet (Harry N. Abrams) was Sonia's first graphic novel. She contributed to the Will Eisner Comic Industry Award-winning *Comic Book Tattoo: Tales Inspired by Tori Amos* (Image Comics) and recently published the graphic novel *Marie Curie: A Graphic History of the World's Most Famous Female Scientist* (B.E.S. Publishing). Her work has appeared in *Doctor Who: The Women Who Lived* (Penguin Group UK), *Domo: The Manga* (TOKYOPOP), and *Bravest Warriors: The Search for Catbug* (VIZ Media). Sonia also illustrated the *I Hero* (Hachette), *Girls F.C.* (Walker Books Ltd.), and *Ninja* (Barrington Stoke) children's book series.

Sonia works in other fields as well, including design, film and television, fashion, and advertising. She serves as the company secretary for Sweatdrop Studios, a leading comic collaborative and independent publisher of manga based in the United Kingdom. Sonia loves fashion (particularly Japanese Gothic and Lolita styles), food, and video games. Learn more at www.fyredrake.net.